CW00762832

BEAUTY IN LETTERS

CITY OF M...

...Council Committee...

SECONDED BY Alderman...

Resolved Unanimous...

THAT the Council desire...
on record and to express to...

William Wilk...

...l thanks for the valuable services...
...him during his tenure of the office of

...O MAYOR AND

MAGISTRATE

...the outstanding ability and

JOHN P. WILSON

BEAUTY IN LETTERS

A SELECTION OF
ILLUMINATED ADDRESSES

UNICORN

CONTENTS

FOREWORD

I wonder what art you find beautiful?

It is likely that you admire a variety of art, but have some particular favourites. I find illuminated manuscripts a joy. I am not thinking of medieval books of hours, admirable and interesting as they are; I am thinking more of the artwork from the Victorian times onwards when there emerged a fresh approach to calligraphy. Edward Johnston is thought to have rejuvenated a significant interest in lettering in the late nineteenth and early twentieth centuries, but the illuminated manuscripts to which I refer began earlier, in the early nineteenth century. These are the presentations and addresses to individuals in recognition of a long or distinguished service. I find these very beautiful, but also attractive for many other reasons.

They can have finely detailed calligraphy, embellished with small designs or pictures, requiring a commercial artist who is particularly skilled to produce fine art that is meant to be impressive. They can occur as folders, scrolls or certificates. The size and detail of the artwork, and the housing in which it is presented, would depend on how much the commissioner of the work was willing to spend. The more significant the recipient, the more impressive and expensive the presentation was liable to be. An Edwardian catalogue shows prices ranging from 2 guineas for a simple illumination in a plain folder to 25 guineas for a highly detailed embellished design in a gold frame. The decorative folder bindings, sometimes with metal engraved monograms, are additional, skilled and handsome works of art. What I find adds

to their interest is that each one is unique, usually given to one person at a point in time as a celebration. They almost always represent a happy occasion. They provide a picture of a period in history and each will have a story behind why the presentation was made. They provide an opportunity to obtain an insight into someone's life and achievements, and allow a brief historical opening to social history.

You may wonder what it is about a picture that makes it an illumination. Usually 'illuminated' means the embellishment of lettering with gold, silver or colours.

The presentation of illuminations continues today, but on a very limited basis compared to the past. It is still possible to get the equivalent items by commissioning a calligrapher. The following can be of assistance:

SSI – The Society of Scribes & Illuminators
https://calligraphyonline.org/commissions/

CLAS – The Calligraphy & Lettering Arts Society http://www.clas.co.uk/commissions/

The illuminated addresses presented within this book also illustrate a variety of lettering styles. Many of the Victorian examples use gothic lettering, a formal style established centuries ago. The style uses bold, decorative, upright letters and can be difficult to read. Even when later calligraphers employed lettering styles which are easier to read, such as italics, they might still have chosen to include some gothic letters. There are

examples of illuminated addresses in this selection that include a variety of lettering styles within the same address. Illuminators are liable to have had freedom in the use of lettering and would have developed their own personal variations. Many illuminated addresses do not include the name of the illuminator, but where it is known the illuminator is named.

This book is created to share with you some of the beauty and artistic skills that exist within my accumulation of illuminated manuscripts. My interest started on a holiday to Scotland some years ago when I came across the illuminated addresses presented to the Earl of Hopetoun, when visiting Hopetoun House, near Edinburgh. I was struck by their beauty and artwork, and decided that I should try to acquire some.

The selection in this book covers a period of more than one hundred years, and the addresses have been given not only to individuals who may be wealthy or famous but also to ordinary people who have provided a special service. Some of the addresses were awarded before the individuals were honoured with titles. Where this has happened the name used is without the subsequent title. The examples selected are some of my favourites and cover a variety of topics. I trust that you will like them too.

There is one additional illuminated address included that is not in my collection. Rather, it belongs to the Bank of England, my employer, and is the only one to be found in its archives.

Page 1 of the address to Alderman Sir James Ritchie, Bt given in 1902, illuminated by Sir J. Causten & Sons, London. *See p30 for more details.*

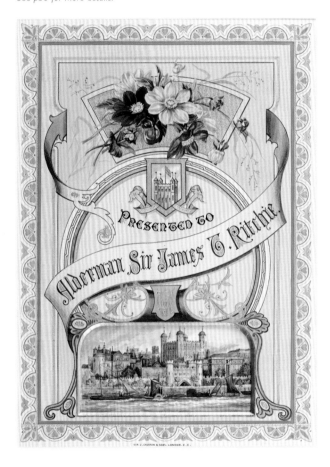

Thanks go to Erica Wilson for ornamental section break symbols, Chris Ison for most of the photography and Kathryn Willig for some vignettes.

This book is dedicated to my wife Rosemary who has tolerated me collecting items over the years and which now fill many bookshelves.

ARMED SERVICES

Soldier
Major John Walford

Captain John Walford was promoted to the rank of Major in 1882 and was presented with a stunning illuminated folder by his regiment. He was a major in the 1st Warwickshire Rifle Volunteer Corps No. 5 Company.

The Volunteer Corps was formed in 1859 as a result of a fear of a French invasion. In 1858 an Italian, Felice Orsini, threw bombs at the carriage of Emperor Napoleon III and his wife Eugénie in Paris. They were unharmed but eight others died and more than 140 were wounded. Orsini had obtained his explosives in England. The French public was outraged by the attack, believed there to be a British conspiracy and called for war. England was largely undefended due to Crimean commitments and so there was a call for a nationwide volunteer army. Emperor Napoleon III did not launch an attack, as he had other distractions, including, in 1859, a war with Austria.

There were many Warwickshire volunteer companies created. In due course these would see action in the Second Boer War and, after becoming part of the Territorial Force in 1908, the First and Second World Wars.

The address to Major John Walford given in 1882.

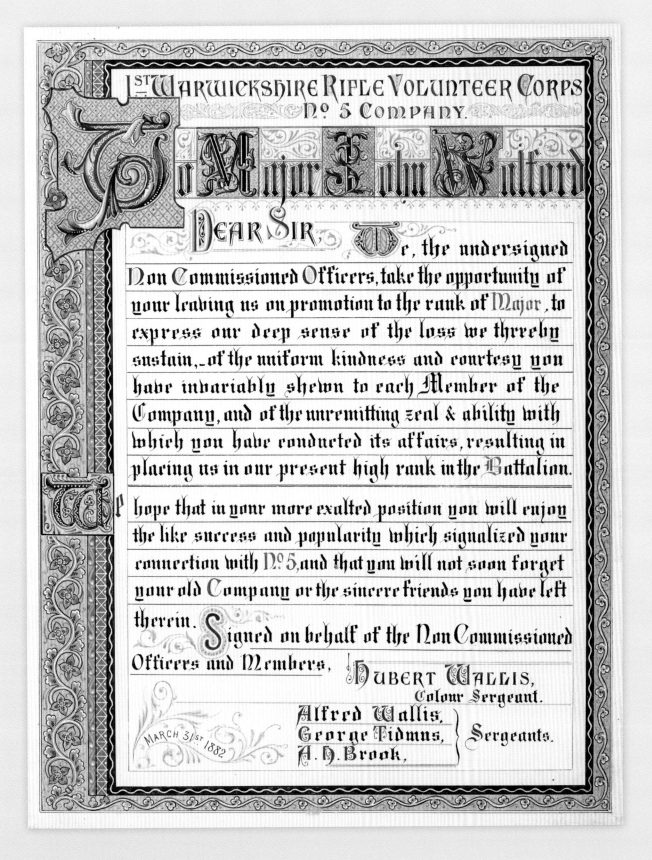

1st Warwickshire Rifle Volunteer Corps
Nᵒ 5 Company.

To Major John Wulford

Dear Sir, We, the undersigned Non Commissioned Officers, take the opportunity of your leaving us on promotion to the rank of Major, to express our deep sense of the loss we thereby sustain,—of the uniform kindness and courtesy you have invariably shewn to each Member of the Company, and of the unremitting zeal & ability with which you have conducted its affairs, resulting in placing us in our present high rank in the Battalion.

We hope that in your more exalted position you will enjoy the like success and popularity which signalized your connection with Nᵒ 5, and that you will not soon forget your old Company or the sincere friends you have left therein. Signed on behalf of the Non Commissioned Officers and Members,

Hubert Wallis,
Colour Sergeant.

Alfred Wallis,
George Tidmas, } Sergeants.
A. H. Brook,

March 31st 1882

BUSINESS

HM Inspector of Taxes
Arthur G. Mead

Illuminated addresses were presented to a wide variety of people, including, on this occasion, an inspector of taxes.

Arthur Mead worked in Runcorn, Chester & District tax district and was given his gift on leaving to take up a position in London – presumably for a bigger, better job, perhaps in HM Treasury. Such a gift feels very generous, as he was only there for three years between 1922 and 1925.

The words in the address seem to stress the onerous nature of the work and the skills of tact and diplomacy shown by Mead. Unusually, this is endorsed by an additional statement at the end of the folder from the Special Commissioner of Taxes who repeats the earlier sentiments. He talks of the many 'delicate and difficult cases that have been so plentiful in this area during the trying times'.

The formal address of two pages is followed by five pages of eighty-four signatures. However, the majority of these are not Mead's colleagues in the tax office but rather local dignitaries and businesses. Individuals include the Superintendent of Police and three local clergymen. Forty-three local businesses are represented, often signed by the relevant managing director.

For those living near Runcorn today, the variety of signatures provides an interesting picture of the local businesses operating in 1922. Most of them probably would not be recognised, as they will have closed or been amalgamated into other businesses with a change of name. For instance, Greenall Whitley & Co. Ltd was probably a well-known brewery, as it had been running since its founding in 1762 in

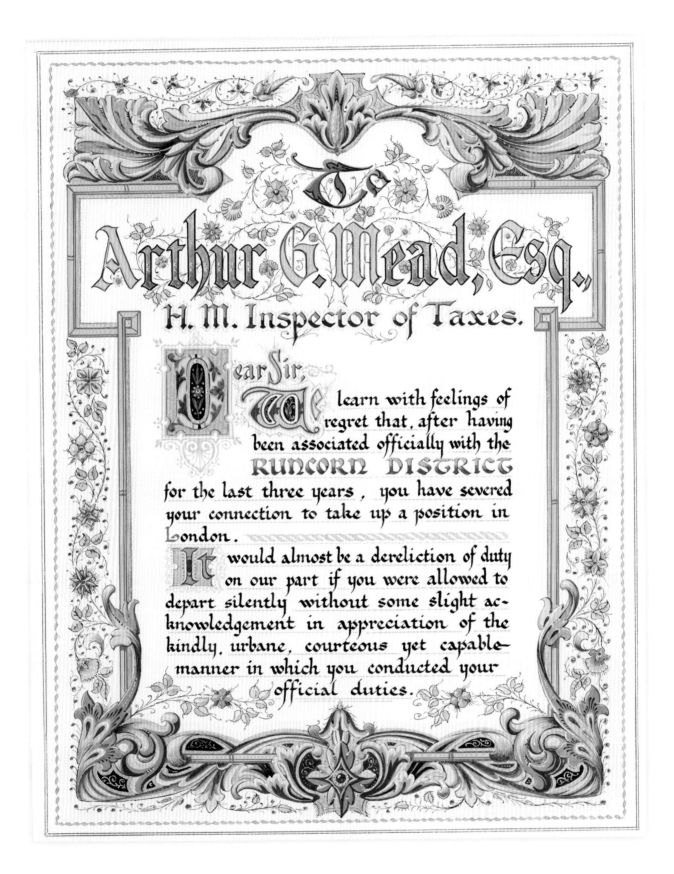

To

Arthur G. Mead, Esq.,

H. M. Inspector of Taxes.

Dear Sir,

We learn with feelings of regret that, after having been associated officially with the RUNCORN DISTRICT for the last three years, you have severed your connection to take up a position in London.

It would almost be a dereliction of duty on our part if you were allowed to depart silently without some slight acknowledgement in appreciation of the kindly, urbane, courteous yet capable manner in which you conducted your official duties.

It is for this reason that we wish to place on record the widespread feelings of esteem with which you are regarded by all sections of the community with whom you were officially brought in contact ~ from the smallest tax-payer to the largest.

Your duties, naturally of an onerous and conflicting character, were invariably done in such a painstaking, tactful manner as to leave no doubt of the sincerity of your intentions to mete out ~ even to the humblest tax-payer ~ absolute justice, and to inspire us with a belief in the genuine desire of the Department you represented to act fairly and uprightly ~ to hold the balance true between the Man and the State, without harshness on the one hand or favour on the other. In short you evoked and won the confidence of the Tax-payer and gave Citizenship an enhanced value of the Honour, the Dignity and the Integrity of the Inland Revenue Department.

Your unfailing kindliness and courtesy to all and sundry in the execution of your duties will long be remembered in the Runcorn area.

We wish you every success in your new sphere of action; and we appreciate to the full the new spirit of kindliness which now seeks to ~ animate the great Department of State of which you are so able, so just, so painstaking an exponent.

Warrington, but it appears to have closed its last brewery in 1990. It is nice to see the signatures of the proprietors of businesses such as A. Timmins, General Manager of E. Timmins & Sons Ltd (Ebenezer Timmins of Bridgewater Foundry, Runcorn, iron founders and well-borers) and H.W. Handley of Horace W. Handley Ltd, iron mongers of 65 High Street, Runcorn.

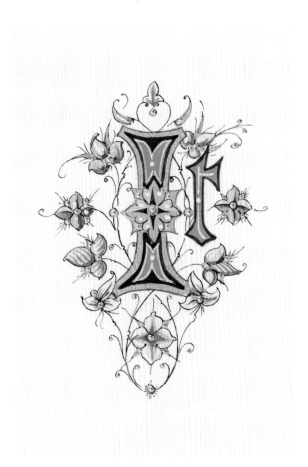

The address to Arthur G. Mead given in 1925.

Insurance manager
Ernest Linnell

When Ernest Linnell retired in 1927, aged sixty-five, as General
Manager of Sun Life Assurance Society, the directors agreed an annual
pension for him of £5,000. Further, they awarded a gratuity of £10,000
for his exceptional value and service over a period of forty-four years,
of which thirty-four were spent as Principal Officer. While he was in
charge, the Society's funds increased from £3m to £30m.

Linnell also received a large and impressive illuminated address from
the members of staff. The address provides the facts and figures for the
Society since he had joined it in 1884, and would have been a helpful
reminder of all the roles and names of the 106 staff in 1894 and the
634 staff in 1927.

Sun Life Assurance Society was a long-established and successful
insurance company. It was established in 1810 with Joshua Milne as its first
employee and appointed actuary. He published *A Treatise on the Valuation
of Annuities and Assurances* in 1815, based on his studies to create new
mortality tables using the mortality bills (burial statistics) of Carlisle. His
work was subsequently used by many other life assurance companies.

Sun Life Assurance Society expanded by acquiring many similar
companies. It was taken over in the 1990s first by UAP, a French insurer, and
subsequently by AXA, which then sold part of its life assurance business
to the Resolution Group, and later the other part to Phoenix Group.

Linnell was born on a farm in Northamptonshire in 1862. His father
farmed 460 acres at Pury Hill in Plum Park and employed eight
workers. The family was well-off, employing five servants. Linnell
moved to Newington, London and was employed initially as an

Page 1 of the
address to Ernest
Linnell given in
1927 illuminated by
Waterlow & Sons
Ltd, London Wall.

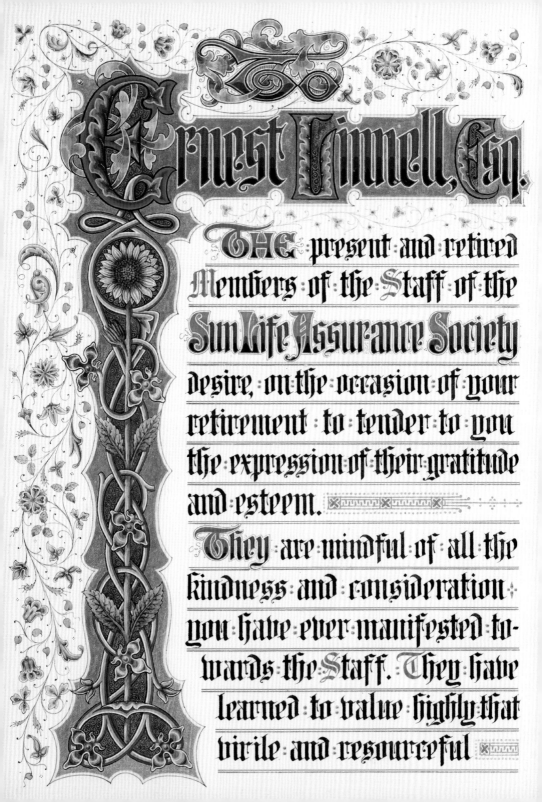

Ernest Pinnell, Esq.

THE present and retired
Members of the Staff of the
Sun Life Assurance Society
desire, on the occasion of your
retirement · to · tender · to · you
the expression of their gratitude
and esteem.

They · are · mindful · of · all · the
kindness · and · consideration ·
you · have · ever · manifested · to-
wards the Staff. They have
learned · to · value · highly · that
virile · and · resourceful

The address to Henry Adams given in 1905
illuminated by John Brown, 8 Gordon Street, Glasgow.

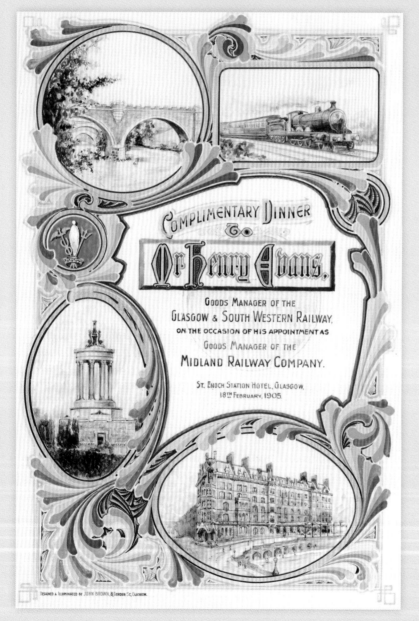

Railwayman
Henry Adams

In 1905 a dinner was held at the St Enoch Station Road Hotel in Glasgow to honour Henry Adams on his appointment as Goods Manager of the Midland Railway Company. Adams had previously been the Goods Manager of the Glasgow and South Western Railway.

The Glasgow and South Western Railway (G&SWR) was formed in 1850 with the amalgamation of the Glasgow, Paisley, Kilmarnock and Ayr Railway with the Glasgow, Dumfries and Carlisle Railway. The majority of its earlier business was transporting coal and other minerals. It formed a partnership with Midland Railway (formed in 1844) and ran services south to St Pancras, London. It lost its name in 1923 when it became part of the London Midland and Scottish Railway, with its headquarters in Derby.

St Enoch Station Hotel was the headquarters of the G&SWR. The corresponding station no longer exists, as both the hotel and it were demolished in 1977.

Food manufacturer
Oliver Horlick

Oliver Horlick was aged seventy when, in 1955, he celebrated fifty years with the company Horlicks Limited, where he was the Chairman. He was presented with a thick volume which begins with an address.

Horlicks was an international company and it appears that every member of staff – home and abroad – signed the volume of ninety pages, many of those with twenty or more signatures. The overseas premises included Malaya, Ceylon, India and Belgium.

Horlicks is famous for its bedtime drink produced in its factory in Slough, Berkshire. However, it started as a baby food manufacturer. The business was created by brothers James and William Horlick, born in 1844 and 1846, respectively, in Gloucestershire. They began their working life as saddlers. William left for Wisconsin, USA to join a relative's building business and did well due to the extensive rebuilding needed after the1871 Great Chicago Fire. James became a chemist with the American Mellin Food Company which produced dried infant food based on a mix of malt and bran combined with milk and water (adapted from a mix known as Liebig's Extract) as a substitute for mother's milk. The formula was

Examples of
Liebig cards.

adapted from the one created by the German chemist Justus von Liebig at the University of Giessen.

Liebig was interested in agriculture and how plants get their nutrients, and his work led to the development of the fertiliser industry. He also created a way of extracting products from beef, and these products were commercially developed by the Liebig Extract of Meat Company. The Liebig Company was based in Fray Bentos in Uruguay, where meat was cheap. It also created and developed the Oxo cube. The Liebig Company marketed itself in various ways, including developing cookery books, calendars and issuing more than 1,800 trade card sets.

Mellin sponsored the making of the UK's first airship in 1902, on which it used its advertising.

James Horlick decided to experiment with his own recipes. However, because he could not raise capital in London, in 1873 he decided to join his brother in the United States. The brothers formed J and W Horlick of Chicago and created a baby food business. They bought a farm with malting equipment and found their products popular. The brothers mixed malted barley and wheat flour with milk and evaporated it until it became a fine powder. The powder could later be added to fresh milk and water to create an attractive drink.

James returned to London to create the Horlicks Malted Milk Company in 1906, with a factory in Ploughlees Farm, near Slough. Like the Liebig Extract of Meat Company and the Mellin Food Company, Horlicks Malted Milk Company used advertising widely. The drink became popular in England and gained fame by providing supplies to Ernest Shackleton's Antarctic expeditions. James was created a Baron in 1914 and died in 1921. William died aged ninety in 1936. Their four sons inherited the business.

The business was sold to SmithKline Beecham for £20m in 1969.

The address to Oliver Horlick given in 1955 illuminated by 'SHEP'.

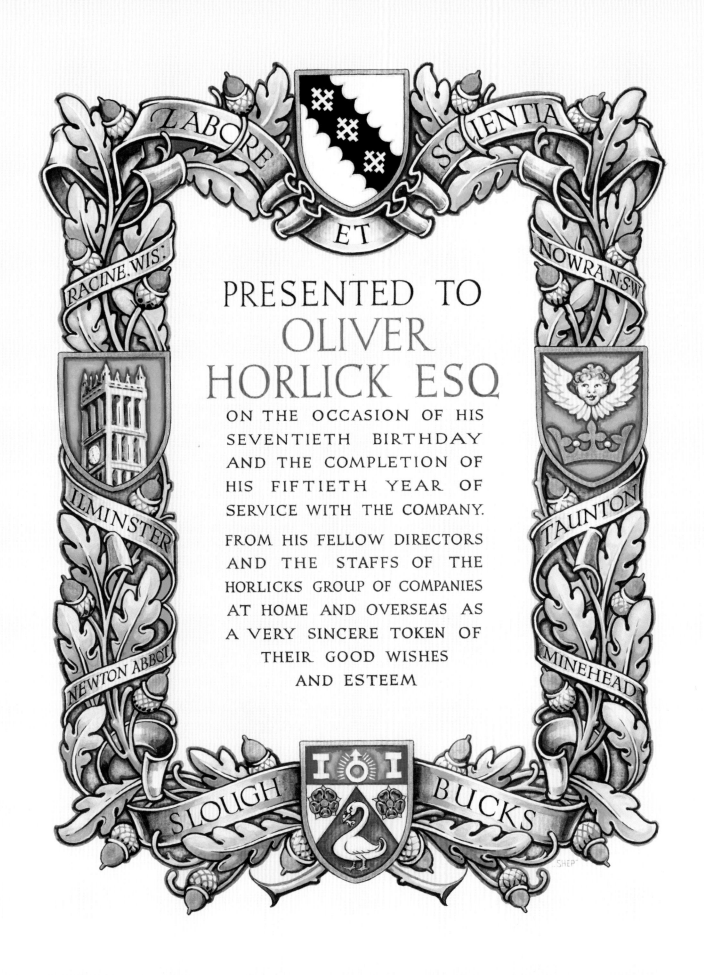

LABORE ET SCIENTIA

RACINE, WIS:

NOWRA, N:SW

PRESENTED TO
OLIVER
HORLICK ESQ
ON THE OCCASION OF HIS
SEVENTIETH BIRTHDAY
AND THE COMPLETION OF
HIS FIFTIETH YEAR OF
SERVICE WITH THE COMPANY.

FROM HIS FELLOW DIRECTORS
AND THE STAFFS OF THE
HORLICKS GROUP OF COMPANIES
AT HOME AND OVERSEAS AS
A VERY SINCERE TOKEN OF
THEIR GOOD WISHES
AND ESTEEM

ILMINSTER

TAUNTON

NEWTON ABBOT

MINEHEAD

SLOUGH

BUCKS

Mill owner
Sir W. Henry (Harry) Hornby, Bt, MP

Here are two illuminations in very different styles.

The first impressive illuminated address, with an equally elaborate tooled cover with a central coat of arms, is housed in a box with a metal monogram.

It was given to Sir Harry by the workers at his cotton-spinning and weaving factory, founded in 1828, at Brookhouse Mill, Blackburn in 1899 when he received his baronetcy. The presentation recognises Sir Harry's contributions as mayor, MP and Chairman of the Education Committee. However, just as importantly it appreciates Sir Harry's concern, support for and kindness to his employees.

Cover of the address to Sir W. Henry Hornby, Bt, MP given in 1899, illuminated by Dugdale & Sons, Blackburn.

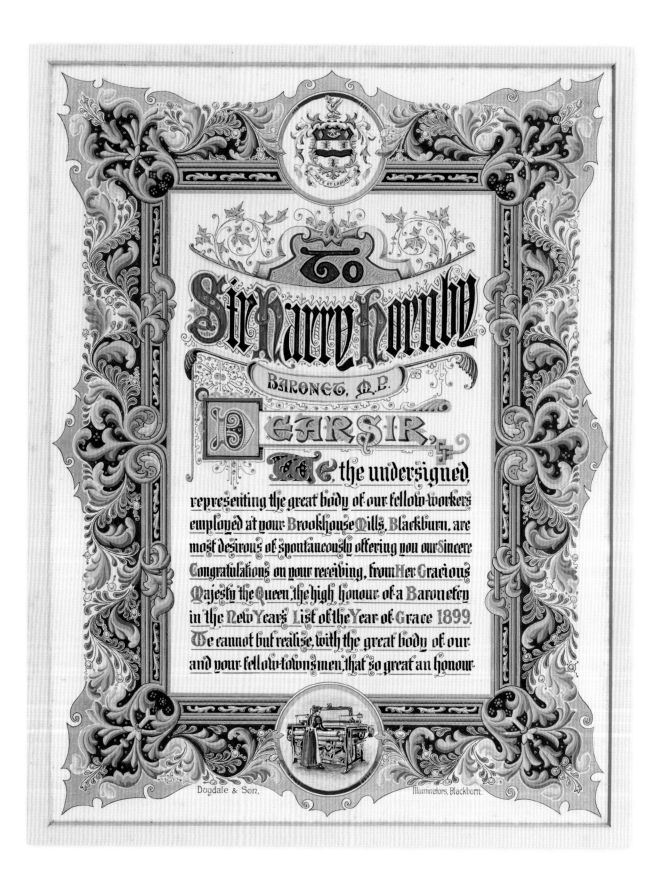

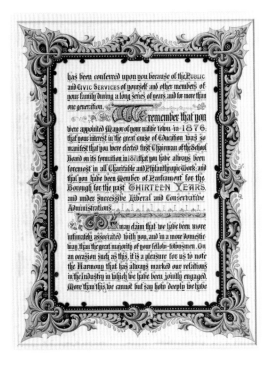

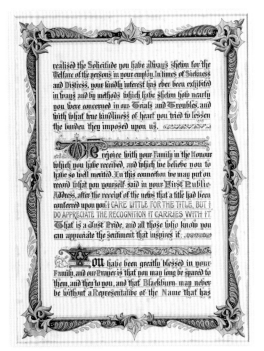

Pages 2, 3 and 4 of the address to Sir W. Henry Hornby, Bt, MP given in 1899.

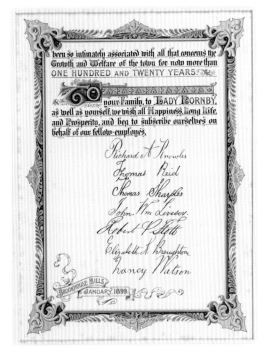

Page 1 of the address to Sir W. Henry Hornby, Bt, MP given in 1899, illuminated by Dugdale & Sons, Blackburn.

The second illuminated address, also of 1899, is much simpler. It is in the format of an embellished letter with gentle watercolour pictures, presented in an encased frame. This was in gratitude to his opening of St Anne's New School.

Sir Harry's younger brother Albert Neilson Hornby was probably better known to the public as he was a cricketer, rugby player and football player. He was selected for Test matches in 1878 and 1882 against Australia. The 1882 match was lost by England and gave rise to the Ashes, when the *Sporting Times* reported that English cricket has died '… the body will be cremated and the ashes taken to Australia'. A.N. Hornby played for England in the first 15-a-side Rugby International against Ireland in 1877 and captained England in 1882 in a win against Scotland. He also played football for Blackburn Rovers in their inaugural game in 1878.

The second illuminated address to Sir W. Henry Hornby, Bt, MP given in 1899.

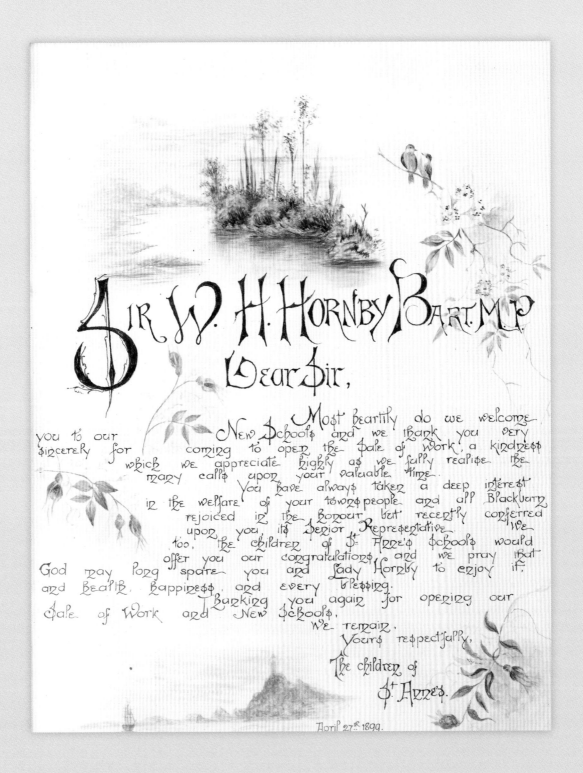

Sir W. H. Hornby Bart. M.P.

Dear Sir,

Most heartily do we welcome you to our New Schools and we thank you very sincerely for coming to open the Sale of Work, a kindness which we appreciate highly as we fully realise the many calls upon your valuable time.

You have always taken a deep interest in the welfare of your towns-people and all Blackburn rejoiced in the honour but recently conferred upon you, its Senior Representative. We too, the children of St. Anne's Schools would offer you our congratulations and we pray that God may long spare you and Lady Hornby to enjoy it, and health, happiness, and every blessing.

Thanking you again for opening our Sale of Work and New Schools,

We remain,

Yours respectfully,

The children of

St. Anne's.

April 27th 1899.

Chairman
Alderman Sir James Ritchie, Bt

Alderman Sir James Ritchie, Bt was Lord Mayor of London in 1903. He was also Chairman of the Jute Association for twenty-eight years and was presented in 1902 with one of my favourite and earliest illuminations, with every page full of exquisite designs.

There are many words from the past that are little used today. Although they may be recognisable, I find that I need a reminder of what they mean. One such word is 'jute', a plant and the name of the fibre from which it comes. It is between 3 ft and 13 ft in length, from which the fibres can be spun into long threads and then into hessian and other cloth. It is versatile and cheap, like cotton. In the 1600s the East India Company started trading in jute, a staple product of the area now known as Bangladesh. Jute was used by the military and British jute traders gained wealth.

Dundee was one centre for the jute business and the East India Company set up jute mills in Bengal, with many Scots emigrating to set up jute factories. More than a billion jute sandbags were used in the trenches in the First World War and they were also used in the United States to bag cotton. Jute was used in fishing, construction, art and the arms industries. Initially it could only be processed by hand until, in Dundee, it was found that if treated with whale oil it could be processed by machine. The industry boomed in the eighteenth and nineteenth centuries but declined in the twentieth century due to the alternative use of synthetic fibres.

Page 1 of the address to Alderman Sir James Ritchie, Bt given in 1902, illuminated by Sir J. Causten & Sons, London.

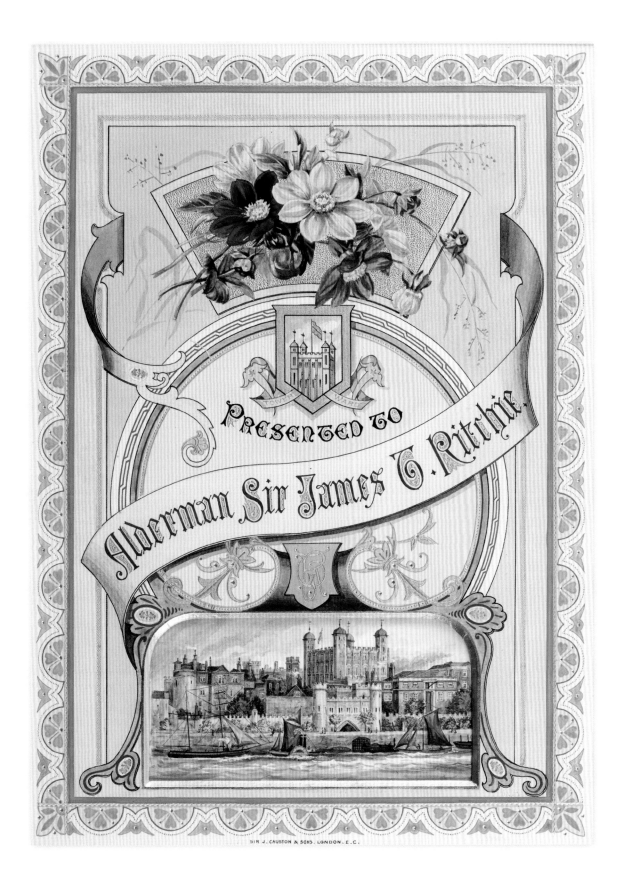

PRESENTED TO
Alderman Sir James T. Ritchie.

TOWER WARD

SIR J. CAUSTON & SONS, LONDON, E.C.

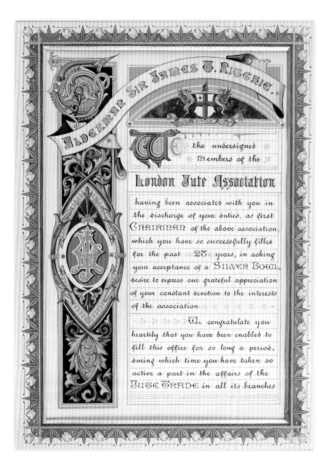

Page 2 of the address.

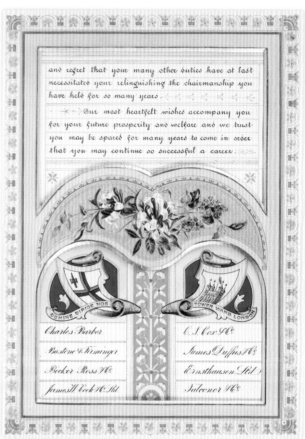

Page 3 of the address.

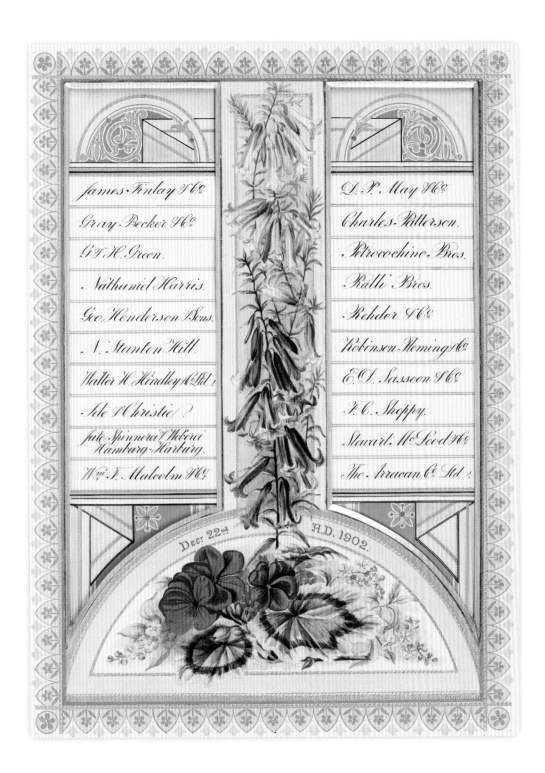

James Finlay & Co.
Gray Becker & Co.
G & H Green.
Nathaniel Harris.
Geo. Henderson & Sons.
N. Stanton Hill.
Walter H. Hindley & Ltd.
Sole & Christie
Jute Spinnerei & Weberei Hamburg-Harburg.
Wm. F. Malcolm & Co.

D. P. May & Co.
Charles Patterson.
Petrocochino Bros.
Ralli Bros.
Rohder & Co.
Robinson Fleming & Co.
E. D. Sassoon & Co.
J. C. Sheppy.
Stewart. McLeod & Co.
The Arracan Co. Ltd.

Decr 22nd A.D. 1902.

Page 4 of the address.

One of the most successful jute-based businesses was run by the Ritchie family in Dundee. William Ritchie, father of Sir James, was head of the firm William Ritchie & Sons of London and Dundee.

Perhaps more famous than Sir James was his younger brother, Charles Ritchie, 1st Baron Ritchie of Dundee, who was Home Secretary from 1900–02 and Chancellor of the Exchequer from 1902–03 in Balfour's cabinet.

Another illuminated address to Sir James came to my collection separately a few years after the first. This was a single, framed picture. It was presented in 1904 by the workers at the Milners Safe Company Limited, operating at the Phoenix Safe Works in Liverpool to honour him for his appointment as Lord Mayor of London and gaining his baronetcy. Sir James was Chairman of the company.

Phoenix Safe Company still operates today. It describes itself as operating as the Richmond Safe Company Limited in 1799, supplying iron-clad wooden strong boxes and sea chests to the maritime trade. Steel reinforced strong boxes developed in Liverpool when a group of migrant workers from Toledo came to Liverpool en route to the United States. Instead, they joined the Richmond Safe Company, which was renamed the Withy Grove Stores in 1850 and the Phoenix Safe Company in 1986. The current company markets a wide range of security products.

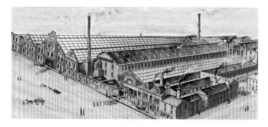

The address to Sir James Ritchie, Bt, given in 1904, illuminated by W.A. Owens, Liverpool.

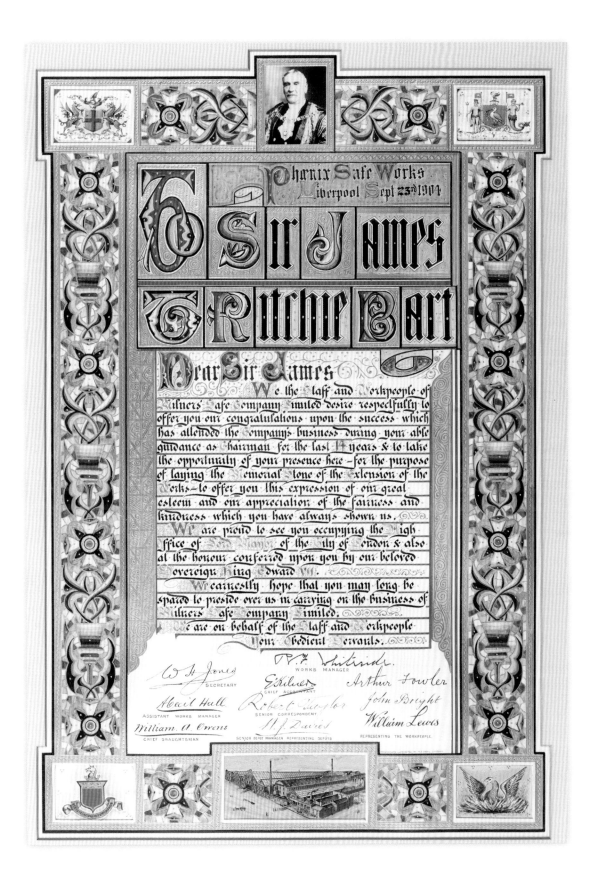

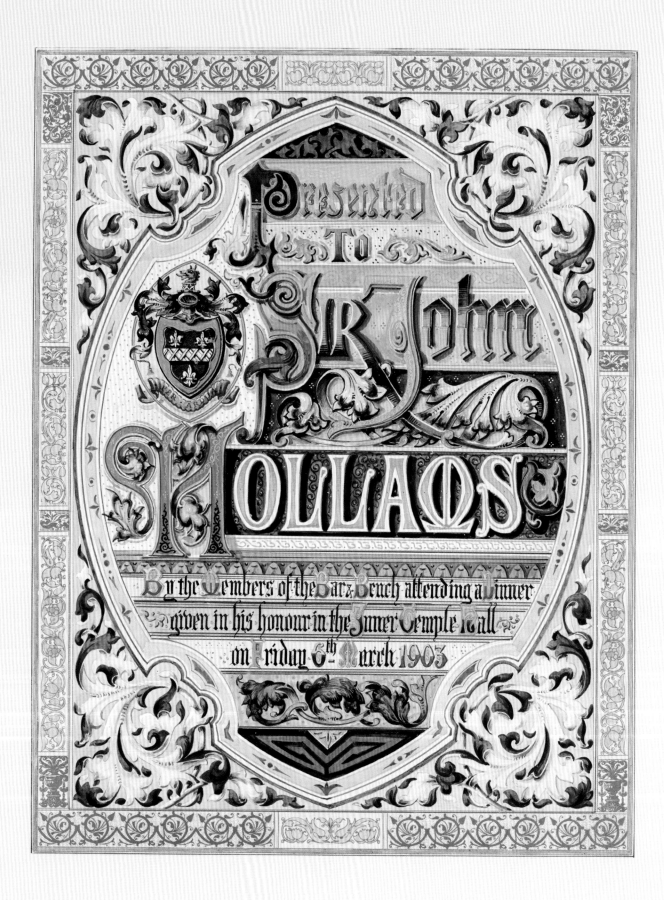

Presented To Sir John Hollams

By the Members of the Bar & Bench attending a Dinner given in his honour in the Inner Temple Hall on Friday 6th March 1903

Lawyer
Sir John Hollams

In March 1903 a dinner was held at the Inner Temple Hall to honour Sir John Hollams and to celebrate his knighthood.

The dinner was a prestigious affair, with the most seniors members of the Bar and Bench present, paying their respects to Sir John following his long career in law. Afterwards, a large illuminated address was presented to Sir John by Lord James of Hereford. The address includes a table plan for the dinner and the signatures of all the guests. There were two toasts, one by the Lord Chancellor Lord Halsbury and the other by the Attorney General, Robert Finlay.

The top table included a number of noteworthy characters, including:

The Right Honourable Hardinge Giffard, 1st Earl of Halsbury, who during his life was appointed the Lord Chancellor three times, who was Grand Warden of the Freemasons and High Steward of the University of Oxford. He also complied the Halsbury's *Laws of England*, well-known to most lawyers.

Lord Alverstone, Lord Chief Justice, who was also President of the Surrey County Cricket Club.

Master of the Rolls, Richard Collins, later Baron Collins and Lord of Appeal in Ordinary.

Sir Roland Vaughan Williams, a Lord Justice of the Court of Appeal and uncle to the composer Ralph Vaughan Williams.

The address to
Sir John Hollams
given in 1903.

Sir James Stirling, a judge, and a Senior Wrangler at Cambridge. The Senior Wrangler is the student with the highest mathematics marks of those who achieve a first class degree in Mathematics at the university. He switched to law as he could not be admitted as a mathematics fellow because he was not a member of the Church of England.

Sir Edward Carson, a judge, who had earlier led the defence of the Marquess of Queensbury against the criminal libel action brought by Oscar Wilde. The Marquess used defamatory words about Oscar Wilde following the latter's relationship with his son, Lord Alfred Douglas. Wilde brought the action but abandoned his case before completion. He still had to pay costs,

A page from the illuminated address

The monogram on the front of the illuminated address cover.

including those of the defence, which he could not afford. He was taken to trial for gross indecency, found guilty and given a two year prison sentence.

Sir James Forrest Fulton, the Recorder of London. He was the judge who sat in the case of Adolf Beck, a famous Victorian fraud case. Beck was convicted of defrauding women of jewellery under a pseudonym, Lord Willoughby. He was convicted, but later given a pardon. A Committee of Inquiry was set up, led by the Master of the Rolls, Richard Collins, which found errors in the original trial evidence, and criticised Judge Fulton's conduct. The case led to the creation of the Court of Criminal Appeal.

The life story of Sir John Hollams is recorded in his autobiography *The Jottings as an Old Solicitor*, published by John Murray in 1906. Here he describes how the law changed during his working lifetime through the nineteenth century, from the time when he first came to London as a young man from his home in Loose, Kent, where his father had been the vicar.

Printer
Sir Philip Hickson Waterlow, Bt

Sir Philip Hickson Waterlow was a baronet, a Doctor of Letters and a Justice of the Peace.

You are likely to recognise the surname Waterlow as the name of the company famous for printing stamps, banknotes and share certificates. Waterlow as a business was founded in 1810. It lasted until 1961 when it was bought by Parnell & Sons. Soon after, Parnell & Sons sold it to De La Rue (the printers of Bank of England banknotes). Waterlow & Sons was started by James Waterlow in London, who created lithograph copies of legal documents. Lithography is a printing process using copies of a picture from an engraved plate.

Waterlow & Sons was involved in a famous trial related to the Portuguese Bank Note Crisis of 1925. The crisis was one of the biggest financial frauds in history with the Banco de Portugal as the victim. The fraud was created by Alves dos Reis, a Portuguese criminal, who drafted a contract for the Banco de Portugal to have Angolan banknotes printed.

The crisis unsettled the Portuguese economy, there was a coup d'état in 1926 and the government fell. It led to the dictatorship of Prime Minister António de Oliveira Salazar from 1932–68. The Banco de Portugal sued Waterlow & Sons in London, winning the case in 1932. Waterlow & Sons had to pay £610,000 in damages, and was never the same again. Sir William Waterlow, Bt, Sir Philip Waterlow, Bt's first cousin once removed, was dismissed as president of the company and died shortly afterwards.

Until 1928 HM Treasury issued treasury notes in England printed by Waterlow & Sons. After 1928 the Bank of England took control of bank

note issues and Waterlow & Sons lost the printing contract. De la Rue won the contract to print Bank of England banknotes from 2003.

James Waterlow, the founder of Waterlow & Sons, had five sons, four of whom joined the company. His fourth son, Sir Sydney Waterlow, became the 1st Baronet. Sir Sidney had five sons, the second of which was Sir Philip.

Sir Sydney was a philanthropist. He gave Waterlow Park in Highgate to the London County Council in 1889. Previously, he had given his home, Lauderdale House, in Waterlow Park to St Bartholomew's Hospital as a convalescent home for the poor. Nurses for the hospital were provided by Florence Nightingale. Lauderdale House dated from the sixteenth century and had been the home of the Duke of Lauderdale, and it is also thought to have been the home of Nell Gwyn, who King Charles II visited.

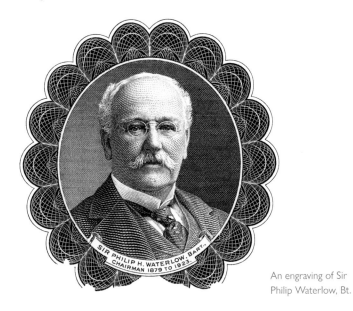

An engraving of Sir Philip Waterlow, Bt.

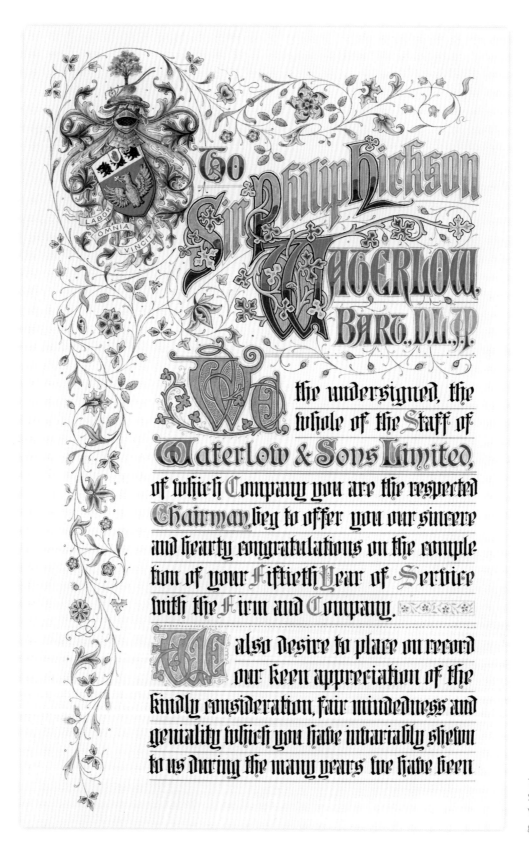

To Sir Philip Hickson Waterlow, Bart., D.L., J.P.

WE, the undersigned, the whole of the Staff of Waterlow & Sons Limited, of which Company you are the respected Chairman, beg to offer you our sincere and hearty congratulations on the completion of your Fiftieth Year of Service with the Firm and Company.

WE also desire to place on record our keen appreciation of the kindly consideration, fair mindedness and geniality which you have invariably shewn to us during the many years we have been

The address to Sir Philip Hickson Waterlow, Bt given in 1914.

associated with you. These attributes, coupled with the quiet confidence with which you have so successfully discharged, for 37 Years, the duties of a most responsible position as Chairman have secured for you the loyalty and affectionate regard of us all and it is to you and your strong personality that the excellent Esprit-de-Corps which obtains in the Company is due.

IN presenting this Address we beg your acceptance of the accompanying Portrait and Sporting Gun with our earnest wish for your long life, happiness, and welfare, and that of your Family.

Name.	Years of Service.	Name.	Years of Service.
Almond, C. R.	36	Black, J. P.	25
Amis, A.	24	Blackaller, C. J.	22
Andrews, W. C.	20	Blott, S.	20
Baker, E. T.	16	Bodell, T. W.	27
Barrett, Miss S.	33	Bond, G. H.	29
Bartlett, G. H.	17	Bowyer, G. J.	30
Berry, J.	15	Bowyer, H. G.	22
Black, G. H.	5	Bradley, M. J.	33

In 1870 Sir Sydney bought large areas of land in Kent, including the village of Fairseat, part of Stansted, and others near Wrotham and Meopham. In 1887 he built Trosley Towers on the North Downs, within the area that is now Trottiscliffe Country Park.

Sir Philip was born in 1849, London and became a baronet on his father's death in 1906.

He became Chairman of Waterlow & Sons and inherited the Trosley Towers estate from his father. He died in Malling, Kent in 1931, leaving an estate worth £297,000. On his death the Trosley Towers estate was sold and later passed to the Kent County Council.

In 1914 Sir Philip was presented with a striking illumination by all the staff of Waterlow & Sons in celebration of his fifty years of long service to Waterlow & Sons, which included thirty-seven years as Chairman. He was also given a portrait and sporting gun.

A page from the illuminated address.

Lord Chancellor
Sir Thomas Wilde, QS, MP

This is an early illuminated address from 1844. The influence on the unknown illustrator of the design of medieval books of hours can readily be seen. The elegant Old English gothic-style lettering, the side panel and embellished letters used at the start of the paragraphs are all similar in style to those used in previous centuries.

This document, called an 'Inscription' by the donors, is in gratitude from the London Vinegar Makers to Sir Thomas Wilde for acting on their behalf and succeeding in obtaining a relief from the duty on vinegar. Fifteen donors are named. All were vinegar-making businesses from around England. At the head of the list is Sir Robert Burnett & Co. of Vauxhall, a business established in 1770 as Distillers, Rectifiers, Wine and Spirit Merchants and Vinegar Brewers. A Rectifier is someone who blends existing alcohol brands and markets the new flavour under a new brand. Sir Robert Burnett & Co. is still famous for its Burnett's Gin.

Sir Thomas was a lawyer, judge and politician. He was famous as a lawyer for two reasons.

First, he gained notoriety in defending Caroline of Brunswick in 1820. Caroline of Brunswick was the Princess of Wales until 1820 when she became Queen Consort, when her husband became King George IV. As Queen Consort she was due to share her husband's social rank and status but not his political and military powers. However, she had become engaged to be married to Prince George, Prince of Wales before they had met, and George was already illegally married to Maria Fitzherbert. Caroline of Brunswick and Prince George married in 1795 but separated in 1796 after the birth of Princess Charlotte of Wales, their only child. Rumours spread that Princess Caroline had

London .xiv June mdcccxliv.

It appearing that in the Bill now before Parliament for repealing the Duty on Vinegar provision is made for the cancellation and return of a portion thereof which has been paid on the stock in hand and yt this provision was obtained by the active interposition and persevering remonstrance of Sir Thomas Wilde, Q.S. M.P. on behalf of the Trade.

Resolved unanimously at a meeting of the Vinegar trade holden this day

That the cordial thanks of this Meeting be offered to Sir Thomas Wilde Q.S. M.P. for his persevering and successful exertions in obtaining for the Trade at the hands of Government an act of justice which it is believed would without his interposition have been refused

That Sir Thomas Wilde be requested to accept from the Trade a piece of plate as a testimonial (however inadequate) of their high appreciation of his persevering and effective services in their cause with the following inscription "To Sir Thomas Wilde QS MP in grateful acknowledgment of important services rendered to the donors. ∞∞∞∞∞∞∞∞∞∞∞

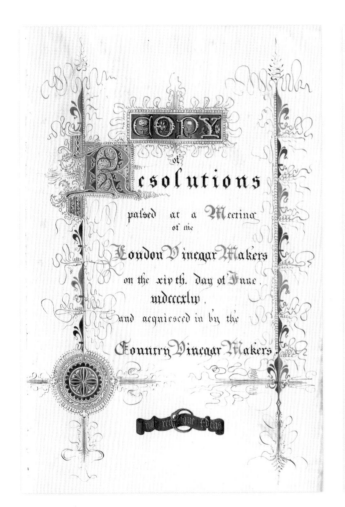

COPY

of

Resolutions

passed at a Meeting
of the

London Vinegar Makers

on the xiv th. day of June

mdcccxliv.

and acquiesced in by the

Country Vinegar Makers

[names of the donors]

Sir Robert Burnett & Co........Vauxhall.

Mr. George Clarke.............Upton on Severn.

Messrs. Forster & Bird........Cambridge.

Messrs. Grimble & Co.........Albany St. Regents Pk.

Messrs. Hill, Evans & Williams Worcester.

Messrs. Hills, Son & Underwood. Norwich.

Messrs. B.G. Kent & Co.......Upton on Severn.

Mr. J.P. Osborne.........Colchester.

Messrs. J. Panter & Co........Bristol.

Messrs. Pomroy & Slee......Horsley Down.

Messrs. C.A.& W. Pott......Southwark.

Messrs. Purnell & Co......Bristol.

Messrs. Swann & Co......Stockport.

Mrs. Waddington.......Birmingham.

Messrs. Willis & Wright... Old St. London.

The address to Sir Thomas
Wilde, QS, MP given in 1844.

lovers and had given birth to an illegitimate child, but an investigation showed no substance in the rumours. Princess Caroline had limited access to her daughter and moved to Italy in 1814 where new rumours began that she had taken her servant as her lover. Back in England, her daughter Princess Charlotte died in childbirth. Prince George requested a divorce but Princess Caroline refused. When he ascended the throne in 1820, Princess Caroline returned to England to claim her right as queen. King George IV tried to obtain a legal divorce through a Bill to Parliament, using evidence of Princess Caroline's infidelity, but it did not succeed. He was not a popular king due to his own immorality, and the public sought political reform, while Princess Caroline had significant support. Unfortunately, she died in 1821.

Secondly, Sir Thomas was a joint founder of the lawyers Wilde Sapte, later to become Denton Wilde Sapte LLP and then SNR Denton.

He became Lord Chancellor in 1850 and was created the 1st Baron Truro. He married twice, his second wife being Mademoiselle d'Este, daughter of Prince Augustus Frederick, Duke of Sussex who was a first cousin of Queen Victoria. Sir Thomas died in 1858 and has a blue plaque to his name in London at 2 Kelvin Avenue, Bowes Park.

Long service
Thomas Hayes

This is an illumination where a number of pages are decorated fully in a delightful Art Nouveau style. The colours are bright and there is a wonderful combination of calligraphy, small detailed pictures, gold highlighting and a connection with a national business with which we, in the UK, are all liable to be familiar: the Co-op.

The presentation was given to Thomas Hayes in 1909 on his eightieth birthday after forty years of service with the Co-operative Wholesale Society (CWS) in Crumpsall, 3 miles north of Manchester. Hayes was a manager in the Biscuit Works, which had opened in 1873, and made biscuits, cakes, sweets, toffee and drugs. The Works boasted being the only eight-hour day biscuit works in England and was progressive in having a cricket club, football club, tennis courts, bowling green, recreation ground, discounted dining room, library, board and card games, and frequent social events such sports days, dances and whist-drives for its staff.

 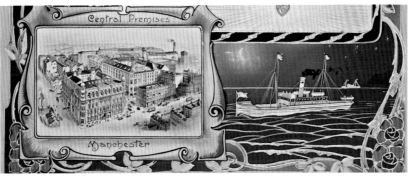

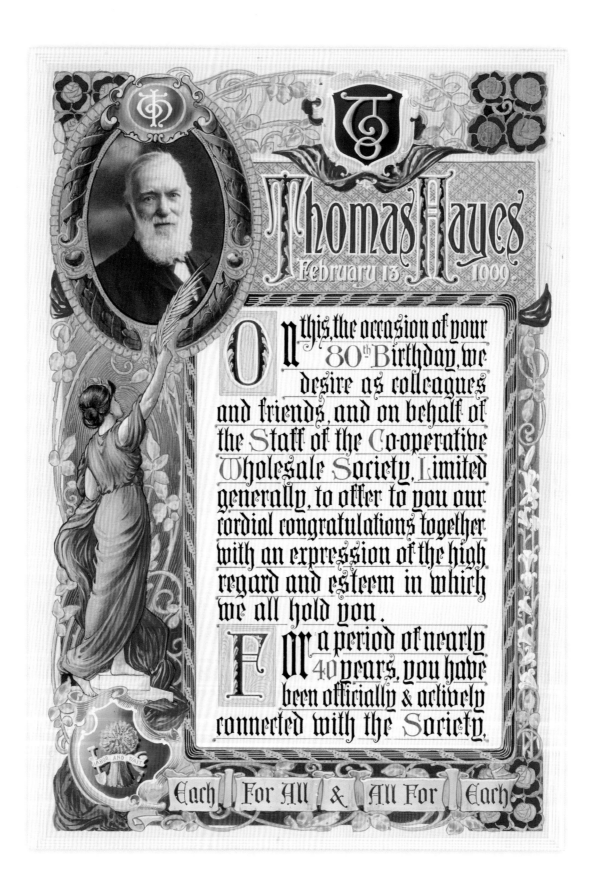

Thomas Hayes
February 13 — 1909

On this, the occasion of your 80th Birthday, we desire as colleagues and friends, and on behalf of the Staff of the Co-operative Wholesale Society, Limited generally, to offer to you our cordial congratulations together with an expression of the high regard and esteem in which we all hold you.

For a period of nearly 40 years, you have been officially & actively connected with the Society,

Each For All & All For Each

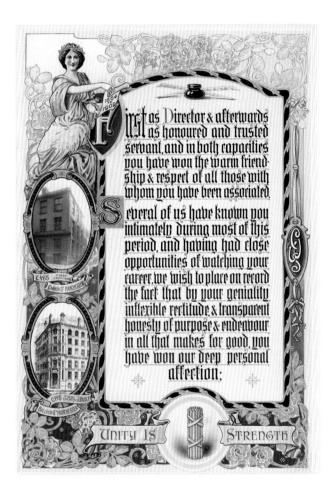

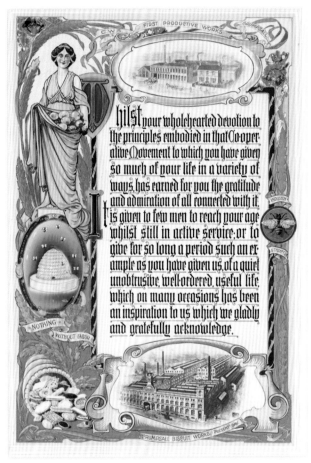

Pages of the address to Thomas Hayes given in 1909, illuminated by CWS Printing Works, Longsight.

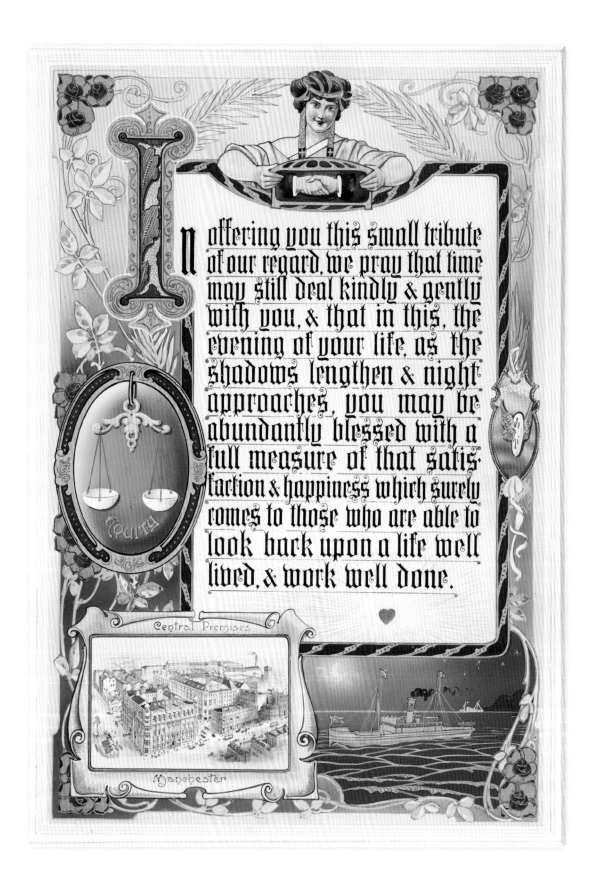

In offering you this small tribute of our regard, we pray that time may still deal kindly & gently with you, & that in this, the evening of your life, as the shadows lengthen & night approaches, you may be abundantly blessed with a full measure of that satisfaction & happiness which surely comes to those who are able to look back upon a life well lived, & work well done.

Central Premises

Manchester

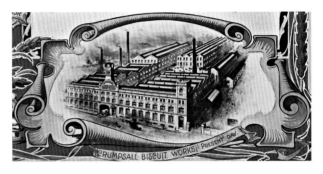

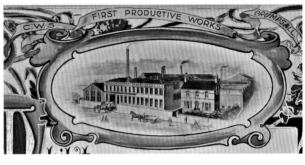

Hayes had been one of the first members of the Failsworth Industrial Society, formed in 1859 with a co-operative grocery shop. Failsworth is halfway between Oldham and Manchester. Hayes was its first secretary and drew up the rules based on the Rochdale Society of Equitable Pioneers.

The CWS began in 1863 and Failsworth was one of its first shareholders, with Hayes as a part-time director. He also became a director of the Co-operative Newspaper Society and Co-operative Printing Society. Failsworth Industrial Society celebrated its Golden Jubilee in 1909, when it had 10,000 members and forty-three shops. It was a pioneer of a number of new societies, including the United Co-operative Laundries, Manchester and District Funeral Association and United Co-operative Dairies. Failsworth Industrial Society lost its name in 1929 when it merged with New Moston Society.

CHURCH

Clergyman
The Rev. Henry William Burrows

The Rev. Henry William Burrows was the vicar of Christchurch in Albany Street, St Pancras, London until 1878 when he retired and was given, in gratitude, an elegant illuminated presentation by the parishioners.

He was born around 1816 in Malta. He married Maria, seven years his junior, and they had at least four children. They must have been reasonably well-off, as they had four servants. Burrows was appointed a perpetual curate in 1850. He could not call himself a vicar until 1868 and before then had to be referred to as a perpetual curate or parish priest. As a perpetual curate this meant that he could not be removed other than by a bishop, and as a curate he was a 'cure of souls'. Perpetual curates were lower paid than vicars, usually reliant on pay from an endowment, while vicars had the right to a tithe from the parish. The title 'perpetual curate', with a history dating back to the sixteenth century, disappeared in 1868.

The appointment document of the Rev. Henry William Burrows as a Canon in Rochester Cathedral in 1881.

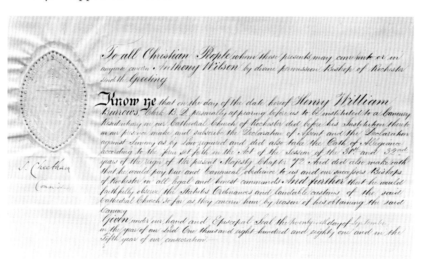

Page 1 of the address to the Rev. Henry William Burrows given in 1878.

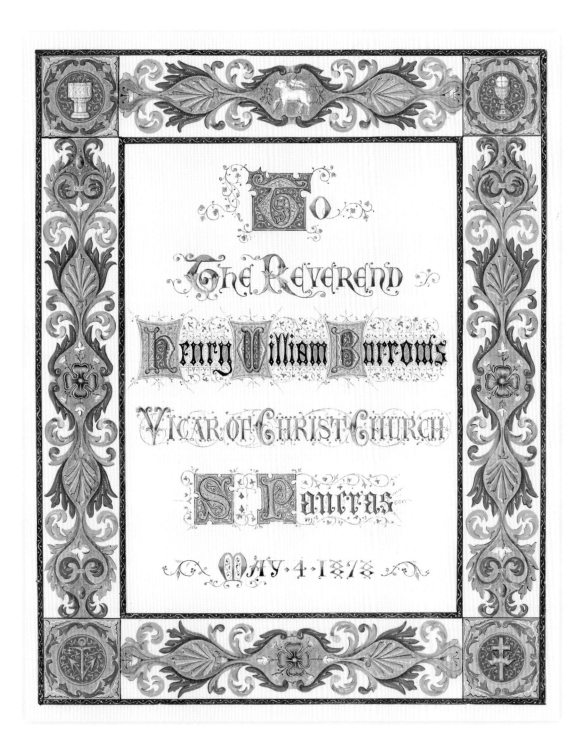

To
The Reverend
Henry William Burrows
Vicar of Christ Church
S. Pancras
May · 4 · 1878

The cover of the address to the Rev. Henry William Burrows given in 1878.

Christchurch was built in 1837 for the parish next to Regent's Park, London, now part of Camden. The church is now St George's Cathedral, London for the Antiochian Orthodox Church. The city of Antioch, near Antakya in southern Turkey, close to the Syrian border, is now in ruins. It was founded in the fourth century BC, and became one of the largest cities in the Roman Empire. Antioch has a long history of Christianity, thought to have begun with St Peter, and the place where followers of Jesus were first called Christians. It was the capital of Syria until the capital was moved to Damascus by the Mamelukes, due to Antioch's earthquakes.

Page 2 of the address to the Rev. Henry William Burrows given in 1878.

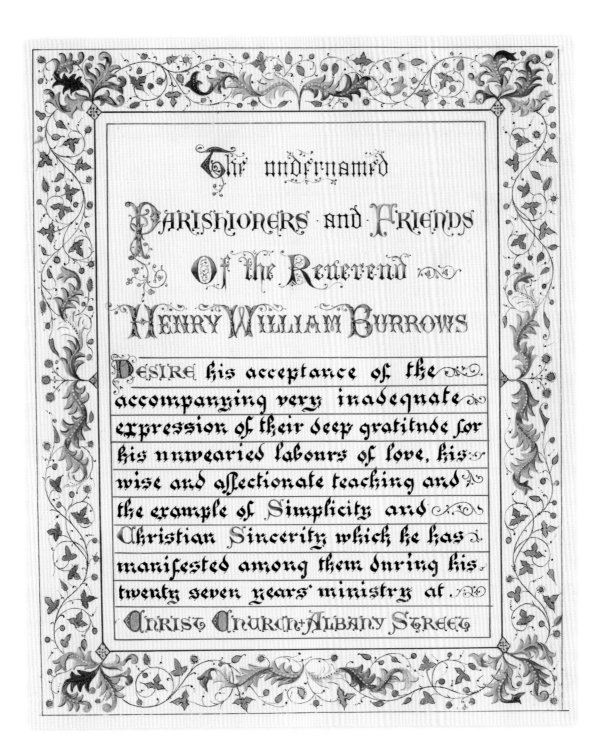

The undernamed

PARISHIONERS and FRIENDS

Of the Reverend

HENRY WILLIAM BURROWS

DESIRE his acceptance of the
accompanying very inadequate
expression of their deep gratitude for
his unwearied labours of love, his
wise and affectionate teaching and
the example of Simplicity and
Christian Sincerity which he has
manifested among them during his
twenty seven years' ministry at

CHRIST CHURCH ALBANY STREET

A long family tree
Robert John Dobrée

This illuminated address is to Robert John Dobrée, presented in 1875 in gratitude for his 'zealous cooperation' in the purchase and erection of the New Vestry Hall in the parish of St Clement Danes, London. It was signed by the Rev. R.J. Simpson as Chairman on behalf of the Vestry.

St Clement Danes Church is on the Strand, near the Royal Courts of Justice, and is known as the central church of the Royal Air Force. It is thought to have been founded by the Danes in the ninth century, albeit the current building is a restoration of a Sir Christopher Wren building which was bombed in the Second World War.

Pews and chairs in the church include those presented by those connected with the Royal Air Force, including Group Captain Sir Douglas Robert Bader and the Guinea Pig Club, which was a social club for air crew injured in the Second World War who had been patients of Archibald McIndoe, the surgeon at Queen Victoria Hospital in East Grinstead, Sussex. McIndoe was famous for developing treatments of burns with plastic surgery.

This illumination might be quickly dismissed as pleasant and only mildly interesting but for the fascinating family history of the Dobrée family. It illustrates how much of a wider story can be gleaned from a single illuminated address.

The arms of Audray, from which Awdry derives.

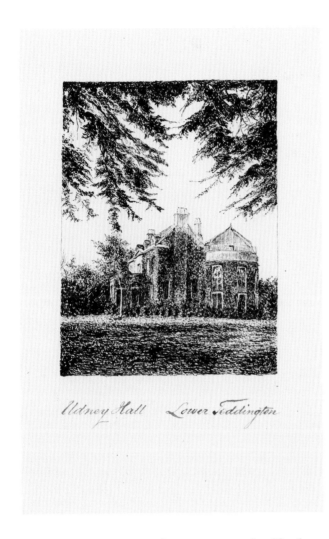

Udney Hall Lower Teddington

Udney Hall.

Dobrée was born close to St-Martin-in-the-Fields, London. He married Caroline Salmon in 1837 and had six children. According to the census, he had a pawnbroking business near Grosvenor Square and lived in Hampstead. Later he lived in Russell Square.

One of Dobrée's sons, Edward, the third child, was born in 1841 at Atkinson Place, Brixton. He was a successful shipping agent and married Fanny Awdry in 1871. They moved to Udney Hall in Teddington, near Hampton Court. Udney Hall had originally been called Teddington Place and had been owned by Sir Charles Duncombe who bought property from the Marquis of Winchester in 1683. Sir Charles was a wealthy banker and was Lord Mayor of London in 1708. He bought many properties, including land in Twickenham which later was owned by Horace Walpole whose residence was Strawberry Hill. Udney Hall was demolished in 1946 and stood in the land now known as Udney Park Gardens.

Edward was keen on family history. He was diligent and thorough in tracing his own and his wife's ancestry. Fanny had a wonderful pedigree, albeit unauthenticated, in that her family tree could be traced back to Norman times. Her ancestry included Sir Fulke

Greville, who served Queen Elizabeth I and King James I in various roles, including Chancellor of the Exchequer. He was given Warwick Castle in 1604. Through his wife, Elizabeth Willoughby, 3rd Baroness Willoughby de Broke, the ancestry can be traced to the Neville family and back to Joan Beaufort, Countess of Westmorland and daughter of John of Gaunt, son of King Edward III.

Edward was interested in establishing his family's right to bear arms and the College of Arms was able to confirm that a grant of arms was awarded to the Dobrée family in 1726, based on historic seals, likely to have come from France.

Edward could trace his father's ancestry, through the Dobrée name, back through Guernsey to France.

The arms of Dobrée.

The first Dobrées to settle in Guernsey arrived in the middle of the sixteenth century, around 1560, from Normandy, as Huguenots, so as to be able to follow the Protestant religion. Another reason for moving to Guernsey comes from a story in their family history. It is believed that Jehan Dobrée was in the service of Gabriel de Lorges, the 1st Earl of Montgomery who, unfortunately, mortally wounded King Henry II in a jousting tournament in 1559 when a splinter from his lance went through the king's eye. He fled to Guernsey as he was friends with Sir Thomas Leighton, the Governor of Guernsey.

It is believed that Jehan followed de Lorges to Guernsey. His wife was Michelle, daughter of John Le Mesurier, a magistrate on Guernsey. (Note that John Le Mesurier, the twentieth-century actor, famous in the television show *Dad's Army*, was born John Elton Le Mesurier

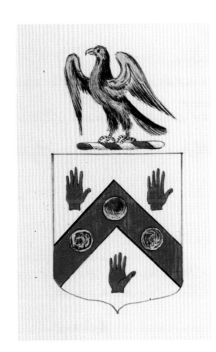

Halliley, with Le Mesurier being the maiden name of his mother, whose family came from the Channel Isles. It seems likely that his ancestry can be traced back to be closely connected to the Dobrée family.)

The Dobrées did well in Guernsey, but some of them returned to France. One descendent, Thomas Dobrée, was an avid and extreme collector and created a palace to house his collections in Nantes (only completed after his death). His objects included books, paintings, coins, medals engravings and sculpture. Thomas died in 1895 and left his palace and collections to the Département de Loire-Inférieure which then called it the Musée Thomas Dobrée, and which still exists today

The arms of
Le Mesurier.

Many of the Dobrée descendants migrated to England and also did well. For instance, Samuel Dobrée established a merchant and shipping business in Guernsey known as Samuel Dobrée & Son. The Bank of Samuel Dobree & Son was established and lasted for more than 200 years, operating from offices in 7 Moorgate, London. Another Dobrée, Bonamy Dobrée, was Governor of the Bank of England from 1859–61.

Thomas Dobrée.

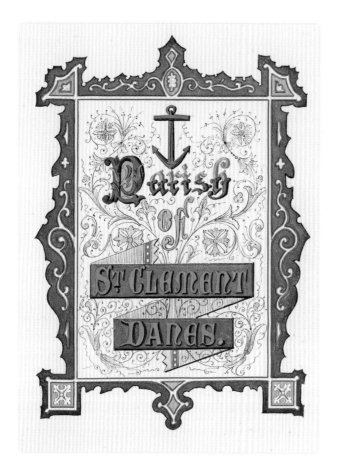

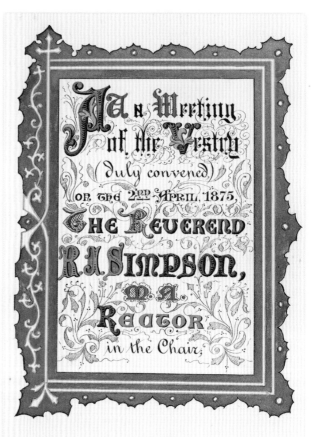

Pages 1 and 2 of the address to Robert John Dobrée given in
1875, illuminated by Peters & Co., Warwick House, Gray's Inn.

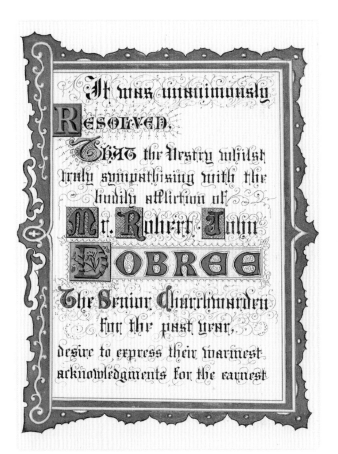
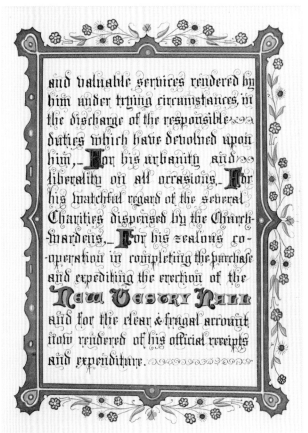

Pages 3 and 4 of the address to Robert John Dobrée given in
1875, illuminated by Peters & Co., Warwick House, Gray's Inn.

Sunday school teacher
William Harrison

This is a small but beautiful illumination that begins with a skilfully painted coat of arms.

The presentation is actually to The Misses Harrison and William Harrison of Arlington House, Knaresborough. It was the closure of the Forest Lane Mission Room in Knaresborough in 1890 that led the members to give the presentation, in gratitude for the Harrisons' service to the Mission Room.

William Harrison and his sisters Charlotte and Temperance lived at Arlington House on Forest Moor Road. They ran the Forest Lane Sunday School until Charlotte's death in 1902, when the school was transferred to St Andrew's Church. The school was subsequently sold to raise funds for a new church.

William, Charlotte and Temperance were the children of Thomas Harrison, a banker. The family were religious and supportive of education and the poor. Charlotte opened a Sunday School in 1854 with the support of her father.

Knaresborough is a small market town within the Borough of Harrogate, North Yorkshire. It has a Norman castle where, in 1210 it is believed that King John distributed the first alms to the poor at the Maundy service. The Maundy service developed from the ceremony of washing feet of the poor, begun when Jesus washed the feet of his disciples on the eve of his Crucifixion. Later, kings and

Coat of arms within the illuminated address to William Harrison given in 1890.

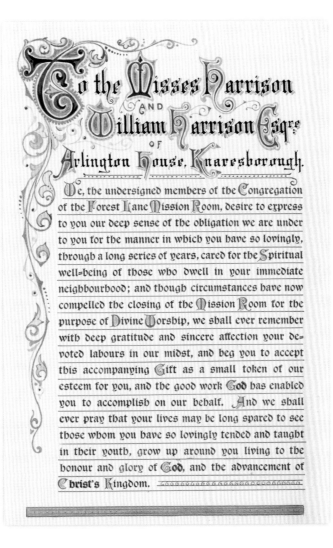

The illuminated address.

queens repeated the practice of giving gifts to the poor and some also washed the feet of the poor. Maundy sets of money comprising 1*d*, 2*d*, 3*d* and 4*d* were first dated from 1670 (but there was an earlier undated set). Currently, it is practice for two purses to be handed out, one containing Maundy money to the value of the same number of pence as the monarch's age, and the other with a £5 coin and a 50p coin.

CIVIC DUTY

Public servant
Alderman Alfred John Knott

Alfred John Knott was an alderman, a chief magistrate and Mayor of Grimsby. He was presented with a wonderful illuminated presentation in 1931 for his services as Mayor.

An alderman is a high-ranking member of a borough or county council. The name derives from elder man, a chief noble who presided over a shire. The name mostly disappeared in 1974 under the Local Government Act 1972, except for London boroughs where the position was abolished in 1978. However, the City of London still has aldermen, elected for each ward by the public. Only people who have been an alderman and a sheriff can be a candidate for the Lord Mayor of the City of London.

Knott was born in Grimsby in around 1865 and stayed most of his working life in the area, working as a fish merchant. He died in 1938. His son Claude, born in 1891, also worked as a fish merchant before

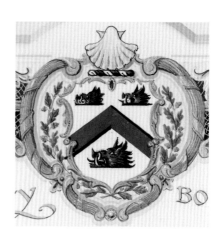

Page 1 of the address to Alderman Alfred John Knott given in 1931.

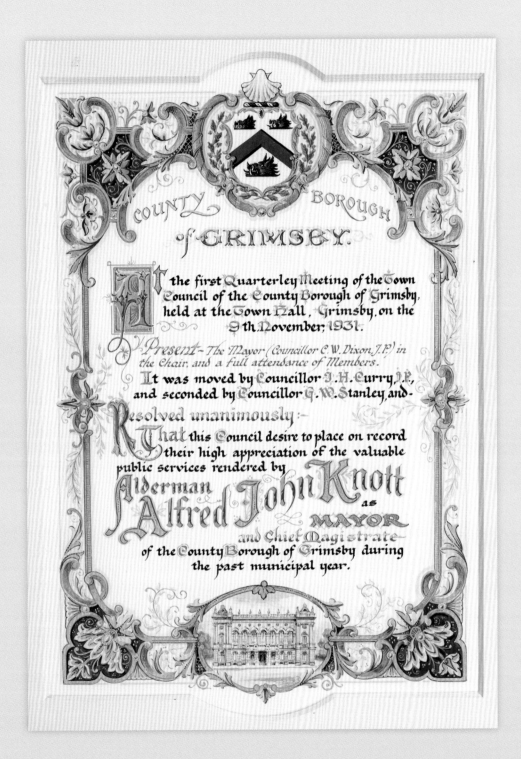

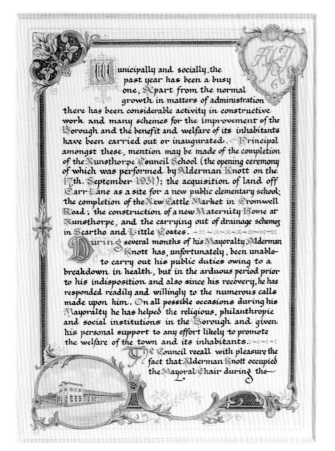

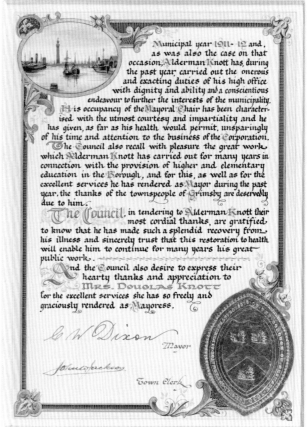

Pages 2 and 3 of the address to Alderman
Alfred John Knott given in 1931.

joining the army with the Lincolnshire Regiment in the Special Reserve
Battalion (No. 3). Claude married Dorothy Compton in 1919 in
Middlesex and died in 1960. Grimsby was a major sea port, having the
largest fishing fleet in the world by the mid-twentieth century, but the
fishing industry declined in the 1970s due to the Cod Wars.

Lord Mayor of Cardiff
Alderman James Hellyer, JP

Alderman James Hellyer retired from the roles of Lord Mayor and Chief Magistrate of Cardiff in 1942. This occurred in the midst of the Second World War and his bright and attractive illuminated address makes reference to war effort fund-raising of £4.5m in Cardiff Warships Week, the Dig for Victory Exhibition and the Stay at Home Holidays campaign. The address also notes his hospitality to the Princess Mary, the Princess Royal and Princess Alice, the Duchess of Gloucester, both aunts of Queen Elizabeth II.

The address illustrates the splendid arms of Cardiff. These were granted in 1906, but with subsequent amendments. The shield shows a red dragon next to a leek, and the dragon is holding a standard with

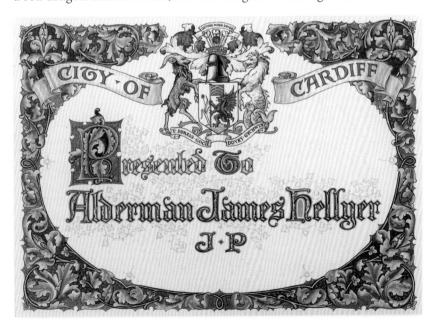

Page 1 of the address to Alderman James Hellyer, JP given in 1942.

arms thought to be of the last Prince of Glamorgan. Under the shield is a motto meaning the red dragon will lead the way.

The crest at the top has a Tudor Rose on three ostrich feathers sitting on a crown. The motto above the crest means awake, it is day.

The animals (supporters) either side are a goat, an emblem of the Welsh mountains, and a seahorse, to represent the sea and commerce to Cardiff port. There are five small photos depicting Cardiff in 1942: the City Hall, University College, HMS *Cardiff*, Jubilee Cottages Ely and allotments to represent the Dig For Victory Campaign.

HMS *Cardiff* was the second of four ships to bear this name. The pictured ship was in use from 1917–46. She participated in the Second Battle of Heligoland in 1917 and thereafter in the Baltic to support the anti-Bolshevik campaign in the Russian Civil War. In the Second World War she was a patrol ship within the northern patrol seeking German ships and later became a gunnery training ship. She was broken up for scrap in 1946.

Pages 2, 3 and 4 of the address to Alderman James Hellyer, JP given in 1942.

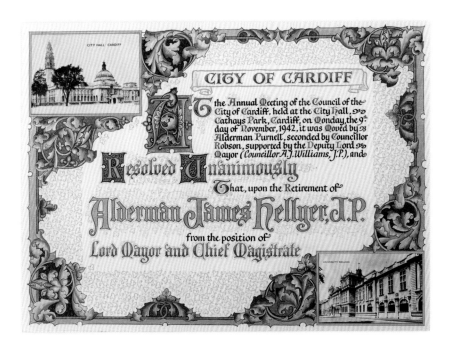

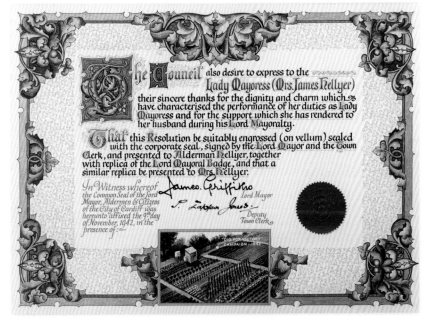

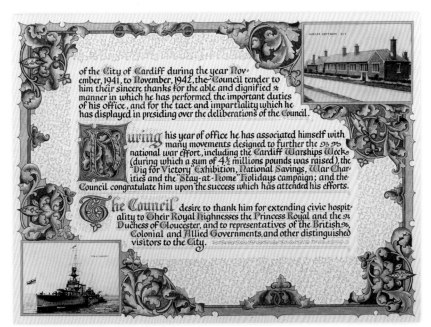

Watch Committee Chairman
Alderman William Hughes

In 1937 Alderman William Hughes was presented with a colourful illuminated address in gratitude for his service as Chairman of the Watch Committee of Salford. He had been a member of the committee since 1895 and had been Chairman since 1920.

The illumination is enhanced by four neat vignettes of municipal buildings: Salford Town Hall in Bexley Square, Salford; Police 'A' Division Headquarters in Regent Road, Salford; Pendleton Police Station, Salford; Police 'C' Division Headquarters in Park Lane, Broughton, Salford.

A Watch Committee was a committee within the local authority that was given the power to oversee local policing, until it was replaced by the introduction of police authorities.

Hughes was given the Freedom of the City in 1941 after serving fifty years as a councillor. There had been only six prior recipients of the Freedom, one of whom was the Rt Hon. David Lloyd George, OM, MP.

Hughes had also been Mayor of Salford from 1919–20. In addition, in 1941 he achieved his seventieth year of membership of the Methodist Church. He had been a Superintendent at the church, which had involved fundraising for a new church and school. It had been his service in the Enys Street Methodist Church that had led a deputation of miners in Pendleton (an inner city suburb of Salford) to approach him to stand as a Liberal working-man's candidate and civil spokesman in the 1891 elections. He supported the miners when they went on strike by suspending his own work and providing a soup kitchen for seventeen weeks.

Page 1 of the address to Alderman William Hughes given in 1937, illuminated by Alan Tabor.

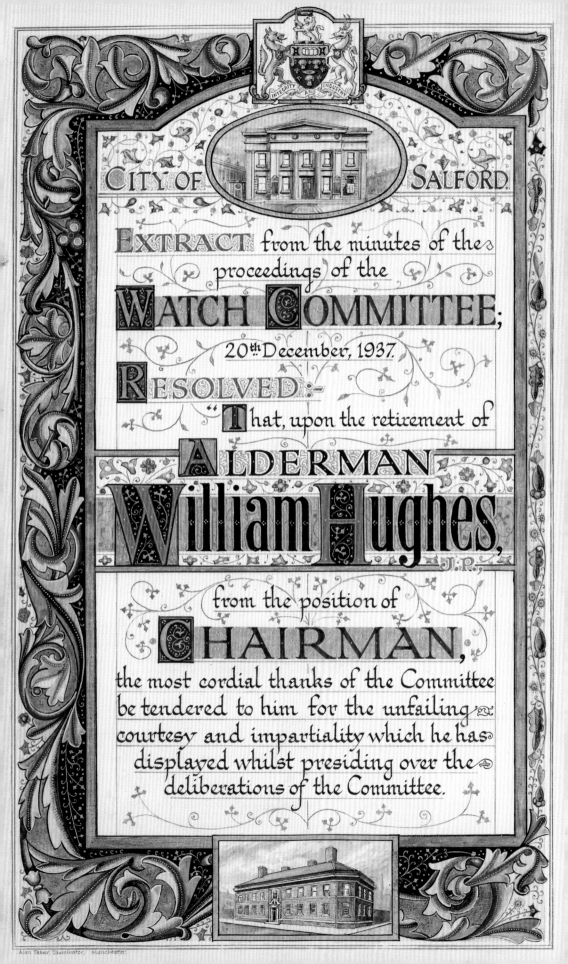

CITY OF SALFORD

EXTRACT from the minutes of the proceedings of the

WATCH COMMITTEE;

20th December, 1937.

RESOLVED:-

"That, upon the retirement of

ALDERMAN William Hughes, J.P.,

from the position of

CHAIRMAN,

the most cordial thanks of the Committee be tendered to him for the unfailing courtesy and impartiality which he has displayed whilst presiding over the deliberations of the Committee.

Alan Tabor, Illuminator, Manchester.

Alan Tabor was the skilled illuminator of the Watch Committee illuminated address. He was based in Manchester and was a commercial artist describing himself as an illuminator. He was widely used. Tabor designed many long service certificates for companies in Lancashire and produced the calligraphy and artwork for a handwritten book, *A Christmas Carol* by Charles Dickens in prose that was published by George Harrap & Co. in 1916. There are examples of his work held by the National Trust in Lanhydrock, Cornwall, Wightwick Manor, West Midlands and Nuffield Place, Oxfordshire.

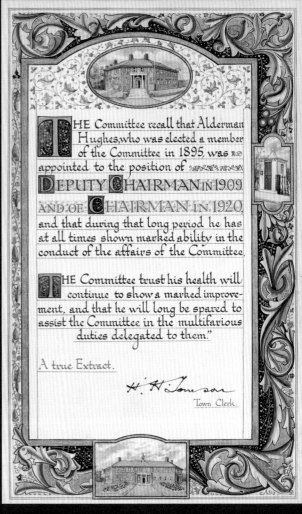

THE Committee recall that Alderman Hughes, who was elected a member of the Committee in 1895, was appointed to the position of DEPUTY CHAIRMAN in 1909 AND OF CHAIRMAN in 1920, and that during that long period he has at all times shown marked ability in the conduct of the affairs of the Committee.

THE Committee trust his health will continue to show a marked improvement, and that he will long be spared to assist the Committee in the multifarious duties delegated to them."

A true Extract.

H. H. Tomson
Town Clerk.

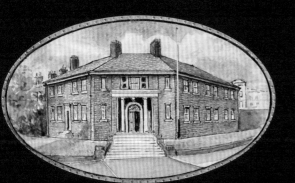

Chairman of the Library Committee
Athro Charles Knight

Some people spend so much time working for their clubs, societies and committees that perhaps they have less time for their families. Athro Charles Knight appears to be such a person. He was married to Violet Evelyn Turner and they had one daughter. It seems that he preferred to be known as Charles.

Knight went to Dulwich College, studied at Lincoln's Inn and rose to become a Senior Partner in the solicitors Mackrell, Ward & Knight. He lived in Herne Place, Sunningdale, Berkshire in a thirty-two-room mansion that later became a recording studio run by Eddie Hardin who had been in the Spencer Davis Group. Now it consists of apartments.

Knight was a London Justice of the Peace, Fellow of the Society of Antiquaries and a Fellow of the Royal Historical Society. He was a member of London City Corporation from 1916, one of the Lieutenants of the City, Deputy of the Ward of Cheap and an Under Sheriff. He was also a member of the London County Council, representing the Municipal Reform Party for Islington North. He was Chairman of the Guildhall Library. For his year of service on the Guildhall Library Committee, in 1923, he was given a lovely illuminated address and an old English silver tea service!

Knight was a founder (in 1914) and President (in 1927) of the City Livery Club. The club's original meeting place was at De Keyser's Royal Hotel. Sir Polydore de Keyser was a Belgian waiter who came to London to make his fortune. He built the 400-room hotel in 1874 near Blackfriars, on the site that later became Unilever House. The hotel hosted many Guildhall banquets and was the first meeting place of the City Livery Club before being demolished in 1930. Having received

British nationality, Sir Polydore became Lord Mayor of London in 1887, the first Catholic to be elected to the office since the Reformation.

Knight was on the Council of the London Topographical Society, on the Executive Committee of the London Society, a director of the French Hospital and Deputy Governor of The Honourable The Irish Society. He was a chairman of the City Police Committee, Commissioner in England for Australia, India, Canada and Africa, a Freeman of the City of London from 1912 and was Master of the Worshipful Companies of Fletchers, Scriveners, Tallow Chandlers and Barber Surgeons. He was also a Commander of the Most Venerable Order of the Hospital of Saint John of Jerusalem.

Knight has work published as well, including *Cordwainer Ward in the City of London, its History and Topography*, and *The Tallow Chandlers' Company: its Origin, a sketch of its History*. He died at the age of seventy-nine. There is a stained glass window in his memory in St Lawrence Jewry church.

The address to Athro Charles Knight given in 1923.

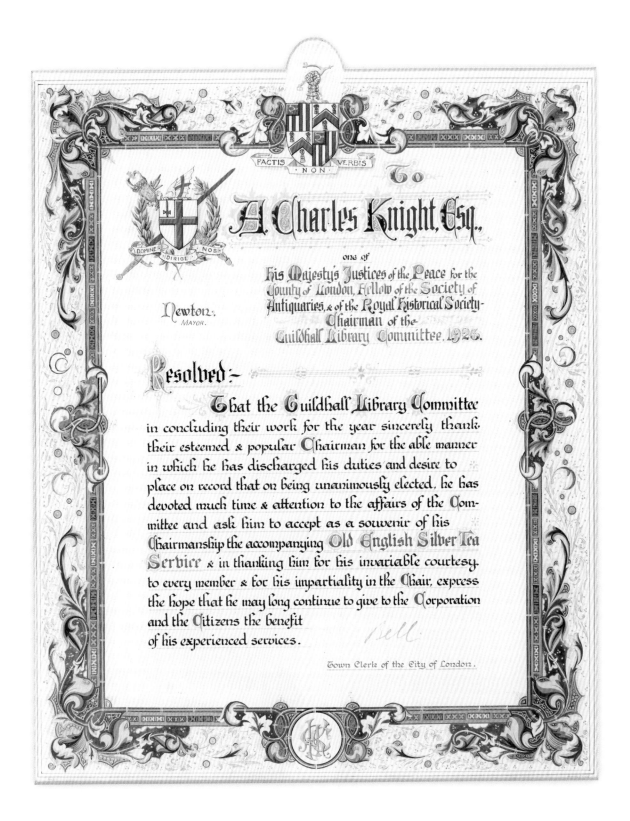

To

A. Charles Knight, Esq.,

one of

His Majesty's Justices of the Peace for the County of London, Fellow of the Society of Antiquaries, & of the Royal Historical Society. Chairman of the Guildhall Library Committee, 1925.

Newton.
MAYOR.

FACTIS · NON · VERBIS

DOMINE · DIRIGE · NOS

Resolved:-

That the Guildhall Library Committee in concluding their work for the year sincerely thank their esteemed & popular Chairman for the able manner in which he has discharged his duties and desire to place on record that on being unanimously elected, he has devoted much time & attention to the affairs of the Committee and ask him to accept as a souvenir of his Chairmanship the accompanying Old English Silver Tea Service & in thanking him for his invariable courtesy. to every member & for his impartiality in the Chair, express the hope that he may long continue to give to the Corporation and the Citizens the benefit of his experienced services.

Town Clerk of the City of London.

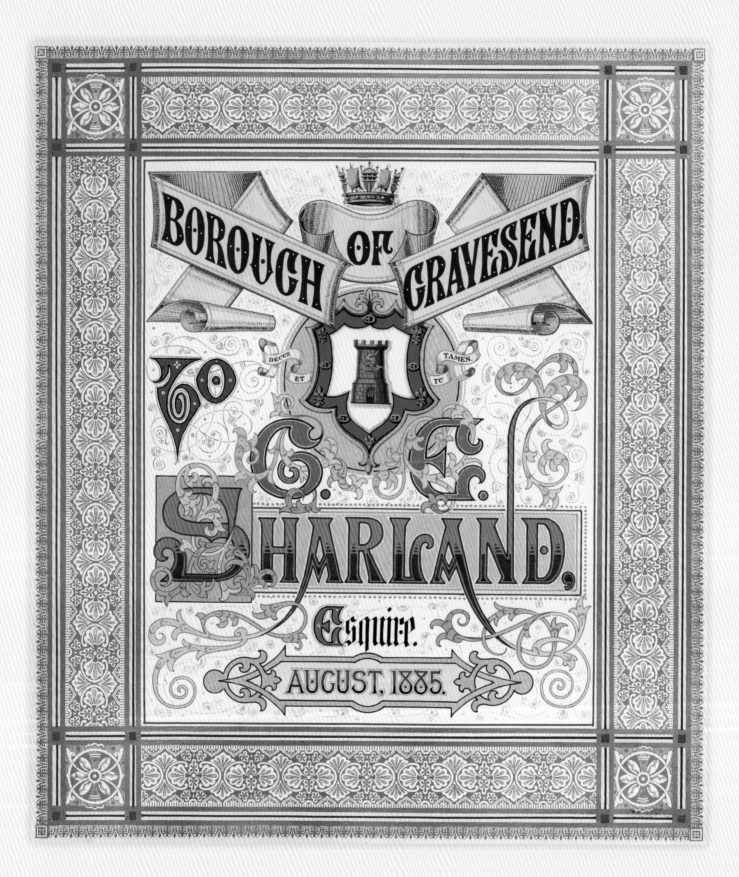

Town clerk
George Edward Sharland

This stylistic illuminated address comes in two sections.

The first section is an illuminated address, part printed (the borders), part designed and painted by hand. It was presented in 1885 by the Borough of Gravesend – when the mayor was Thomas Francis Wood – to George Edward Sharland for his forty years of service as Gravesend Town Clerk. He was also presented with his portrait, painted by J. Haynes Williams.

The second section is another illuminated address eight years later, in 1891, when Sharland retired, signed by George M. Arnold, the then current Mayor. Sharland lived at The Laurels, Milton, Gravesend and was aged sixty-six in 1885. He died in 1900 at the age of eighty-one.

Milton is on the east side of Gravesend, by the Thames estuary, not far from St George's Church where the memorial to Pocahontas is to be found. To understand why there is such a memorial to Pocahontas requires a back story.

Pocahontas was born in the late 1500s to a Chief of the Algonquian tribe, living in what is now Virginia. English settlers arrived in 1607 but were not welcome. When the ships sailed back to England, Captain John Smith and 104 other men were left to fend for themselves through the winter. The need for food brought the settlers into conflict with the Native Americans, Captain Smith was captured and, according to one story, was saved by a young Pocahontas on the point of being put to death.

Captain John Smith returned to England. The friction between settlers and Native Americans continued and Pocahontas was captured and held to ransom. She was taught the Christian faith, baptised as Rebecca

Page 1 of the address to George Edward Sharland given in 1885, illuminated by Waterlow Bros & Leyton, London.

and met John Rolfe, a widower settler. Pocahontas and Rolfe married and had a son, Thomas, and the family of three sailed to England in 1616.

Captain Smith visited the family but was not welcomed by Pocahontas, for breaking promises he had made to her father.

She fell ill and the family chose to sail back to America in the spring of 1617. Pocahontas's health declined severely and

The monogram on the cover of the address.

they were put ashore at Gravesend where she died and was buried in St George's Church. John Rolfe continued his journey to America, married another settler and they had a daughter. Many Americans now claim descent from Pocahontas.

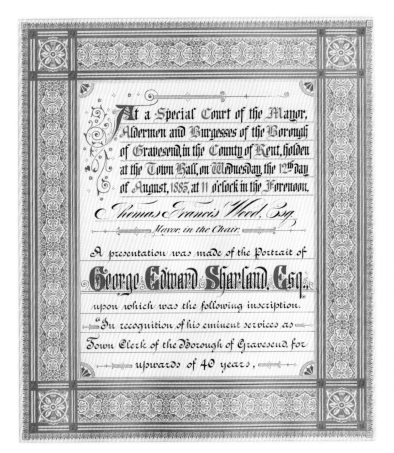
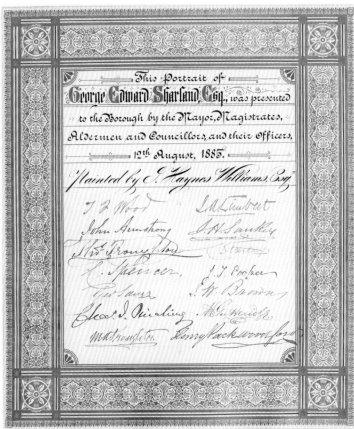

Pages 2 and 3 of the address to
George Edward Sharland given in 1885.

A testimonial
John Death

In 1876 John Death of Cambridge was presented with a silver three-branch epergne (an ornamental centrepiece for a dining table, typically used for holding fruit or flowers), two three-light candelabra and a testimonial providing the inscription words used on the candelabra.

The presentation was in gratitude for Death's two years as Mayor of Cambridge over the period 1873–5, although he was also Mayor again from 1880–82. His gifts were presented by the Master of St Peter's College, Reverend H.W. Cookson, DD. St Peter's College, known as Peterhouse, is the oldest college in Cambridge, having been founded in 1284. The illuminator was F.C. Gower of St Edwards Passage.

Death ran a livery stable in Cambridge and also sat on the Parish Council.

Death laid the foundation stone of the Corn Exchange, on the corner of Corn Exchange Street and Guildhall Street in 1874. It was opened in 1875, with the stone of the building being made from Cornish granite from the Cheesewring Quarry.

According to Cambridge City Council's records, a few days after the Corn Exchange was opened a promenade concert was given by the Coldstream Guards and a local choral society. A mistake made during the playing of the National Anthem led to trouble, including rioters attacking the Mayor's house. A trial resulted and the incident received national attention.

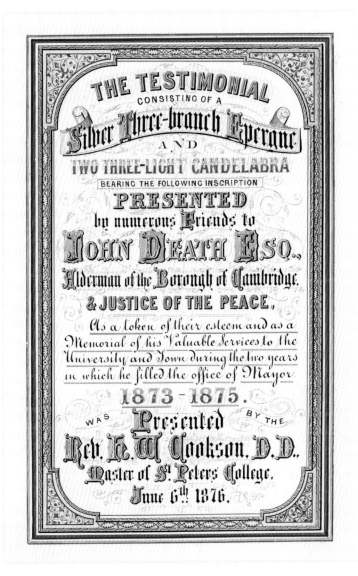

Three pages from the address to John Death given in 1876,
illuminated by F.C. Gower, St Edwards Passage, Cambridge.

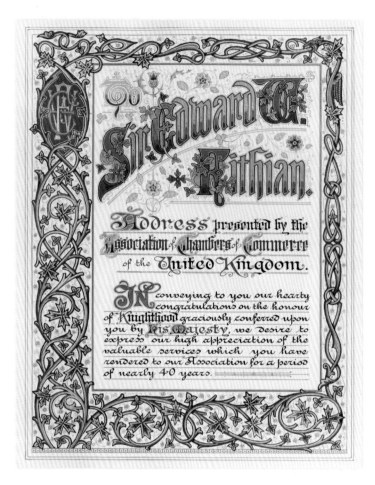

Pages 1 and 2 of the address to Sir Edward W. Fithian given in 1905, illuminated by Waterlow & Sons, London Wall.

'Monkey Town' resident
Sir Edward W. Fithian

Sir Edward W. Fithian was presented with a beautiful boxed illumination, together with 'a piece of plate and purse' in 1905, in honour of his knighthood and in gratitude for his forty years of service to the Association of Chambers of Commerce of the United Kingdom.

Sir Edward was the son of a bookseller, born in Heywood (known as 'Monkey Town'), in 1845. He went to Manchester Grammar School and King's College, London and became a barrister. He took a leading role in supporting commerce. In 1903 he was awarded Officier de

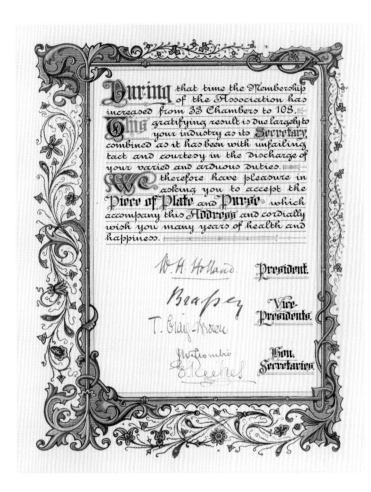

Instruction Publique by President Loubet of France for his services to the promotion of friendly relations between the UK and France.

The naming of Heywood as Monkey Town has an uncertain derivation. It may be based on Heal Bridge being called 'Ape' Bridge due to the derogatory name given to the builders. In the 1840s the Lancashire and Yorkshire Railway was being extended by Irish navvies. Around that time, apes were new to the UK with the first, Tommy, a chimpanzee, arriving at London Zoo in 1835, soon followed by Jenny, an orangutan.

Lord Mayor of London
Sir Rupert De la Bère of Crowborough

I have wondered if Sir Rupert De la Bère's name influenced the naming of Rupert Bear! The name Bère is likely to derive from either fort (ber), swine pasture (baer) or barley (bere), arising in southwest England.

Alderman Sir Rupert was the son of Reginald De la Bère in Addlestone. He went to Tonbridge School, served in the RAF during the First World War and served as a Member of Parliament for Evesham for fifteen years from 1935. He was a director of Hay's Wharf and was a City of London alderman, sheriff and then Mayor.

He was knighted in 1952, and made a baronet and Knight Commander of the Royal Victorian Order in 1953. I assume he chose to be 'of Crowborough' as he lived in the hill-top town in East Sussex, close to the Ashdown Forest, home of Winnie the Pooh and friends.

Sir Rupert was presented with an attractive illuminated scroll in celebration of being elected Lord Mayor of London in 1952. He was also a Knight of the Order of St John of Jerusalem, a Knight of the Order of the Polar Star in Sweden and a Knight of the Order of Dannebrog in Denmark.

He married Marguerite Humphrey, daughter of Lt Col Sir John Humphrey of Walton Leigh, Addlestone, in 1919. Sir Rupert and Marguerite had five children between 1920 and 1939.

The address to Sir Rupert De la Bère given in 1952, illuminated by Norris, 26 King Street, London.

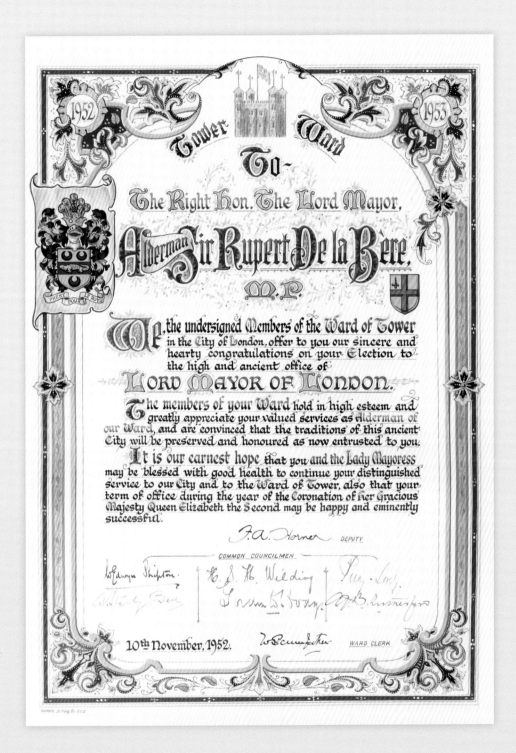

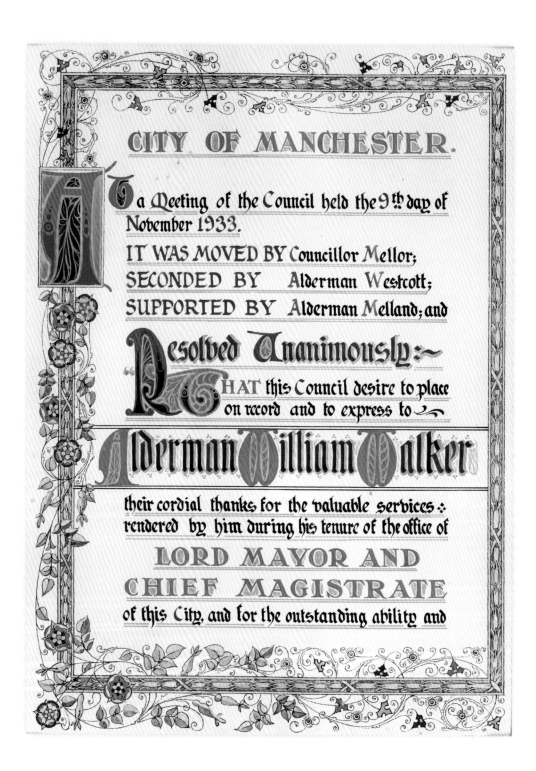

Lord Mayor of Manchester
Alderman Sir William Walker, JP, LLD

Two stunning illuminated addresses were given to Alderman Sir William Walker in 1933 and 1959.

Pages 1 and 2 of the address to Alderman Sir William Walker given in 1933.

In 1933 Alderman Walker was thanked for his service as Lord Mayor of Manchester and Chief Magistrate over the period 1932–3. Also, thanks were given to Lady Mayoress Mrs Davidson Peattie. I have not found why the Mayor and Mayoress had different names!

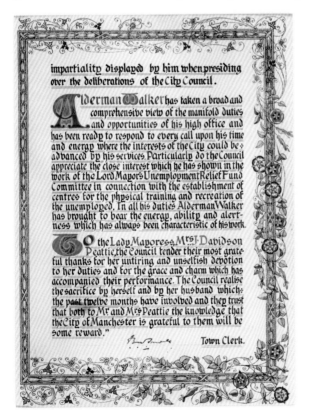

impartiality displayed by him when presiding over the deliberations of the City Council.

Alderman Walker has taken a broad and comprehensive view of the manifold duties and opportunities of his high office and has been ready to respond to every call upon his time and energy where the interests of the City could be advanced by his services. Particularly do the Council appreciate the close interest which he has shown in the work of the Lord Mayor's Unemployment Relief Fund Committee in connection with the establishment of centres for the physical training and recreation of the unemployed. In all his duties Alderman Walker has brought to bear the energy, ability and alertness which has always been characteristic of his work.

To the Lady Mayoress, Mrs J. Davidson Peattie, the Council tender their most grateful thanks for her untiring and unselfish devotion to her duties and for the grace and charm which has accompanied their performance. The Council realise the sacrifice by herself and by her husband which the past twelve months have involved and they trust that both to Mr and Mrs Peattie the knowledge that the City of Manchester is grateful to them will be some reward."

Town Clerk.

By 1959 Walker had become Sir William Walker, JP, LLD and had served fifty years on the City Council.

He worked in the electricity industry as a director of Henry Simon Ltd, which made machinery for the granary and coal industries. The company was founded by Henry Gustav Simon, a Polish immigrant, who made and sold rolling machines for grinding grain. He supplied the first automated rolling machines to McDougall Brothers who milled flour. Machines were sold worldwide, including equipment in the Far East for rice milling. The business evolved by takeover and merger and was subsequently sold to the Japanese firm, Satake Group.

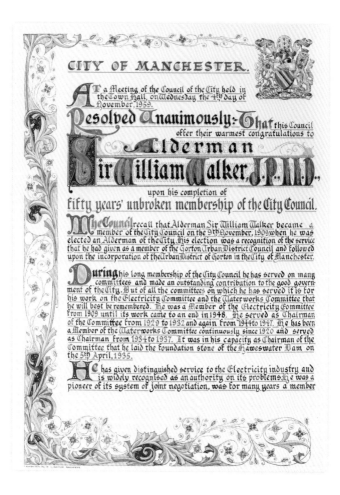

Pages 1 and 2 of the address to Alderman Sir William Walker, JP, LLD given in 1959.

Sir William joined the Manchester City Council in 1909 and particularly supported Manchester's water and electricity supplies. He helped in the acquisition of machinery for the electrical power industry, and laid the Foundation Stone for the Haweswater Dam in Cumbria.

He joined the Central Electricity Board in 1926 and was President of the Incorporated Municipal Electrical Association. He was made a Knight Bachelor in 1945 and awarded an honorary Doctor of Law from the University of Manchester in 1952.

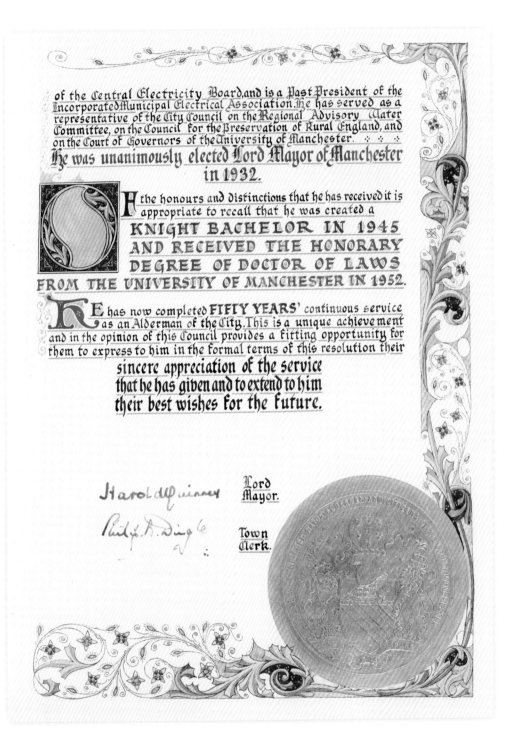

of the Central Electricity Board, and is a Past President of the Incorporated Municipal Electrical Association. He has served as a representative of the City Council on the Regional Advisory Water Committee, on the Council for the Preservation of Rural England, and on the Court of Governors of the University of Manchester. ✦ ✦

He was unanimously elected Lord Mayor of Manchester in 1932.

Of the honours and distinctions that he has received it is appropriate to recall that he was created a

KNIGHT BACHELOR IN 1945 AND RECEIVED THE HONORARY DEGREE OF DOCTOR OF LAWS FROM THE UNIVERSITY OF MANCHESTER IN 1952.

He has now completed **FIFTY YEARS'** continuous service as an Alderman of the City. This is a unique achievement and in the opinion of this Council provides a fitting opportunity for them to express to him in the formal terms of this resolution their

sincere appreciation of the service that he has given and to extend to him their best wishes for the future.

Lord Mayor.

Town Clerk.

CLUBS AND SOCIETIES

The Weir '25' Stag Club
Andrew Alexander Morton Weir, Lord Inverforth

This is a simple but sweet illuminated address in a folder with the presentation on one side and signatures on the other. Lord Inverforth is being thanked by the Weir '25' Stag Club for an inaugural dinner at the Trocadero in 1957. The few words are nicely written, neat and colourful, with a fine watercolour painting of a stag.

Like many illuminated addresses, it is not immediately obvious what the organisation is that is presenting its gratitude and at which Trocadero the event took place in. Therefore, the details that follow are based on supposition.

The 1st Baron Lord Inverforth was Andrew Weir, President of Andrew Weir Shipping and Trading Co. Ltd – ship owners and merchants. *Burke's Peerage* states he was born in 1865, given his peerage in 1919 and died in 1955. He lived at The Hill, North End, Hampstead Heath, later known as Inverforth House, which he bought from the estate of William Lever, 1st Viscount Leverhulme, who established Lever Brothers, the manufacturer of Sunlight Soap, Lux and Life Buoy.

The first baron's eldest son, Andrew Alexander Morton Weir (1897–1975), became the 2nd Baron Inverforth on the death of his father in 1955. Therefore, it would appear that the 1957 illumination was given to the 2nd Baron, the Chairman of the Andrew Weir Shipping and Trading Co. Ltd. Both sons of the 2nd Baron also joined the business.

The company owned passenger ships, cargo ships and oil tankers. The first sailing ship had been bought in 1885 and the first steam ship in Glasgow in 1896. Soon after, the company's ships were registered and known under the name Bank Line. In 2014 it went into voluntary administration.

The address to
Lord Inverforth
given in 1957.

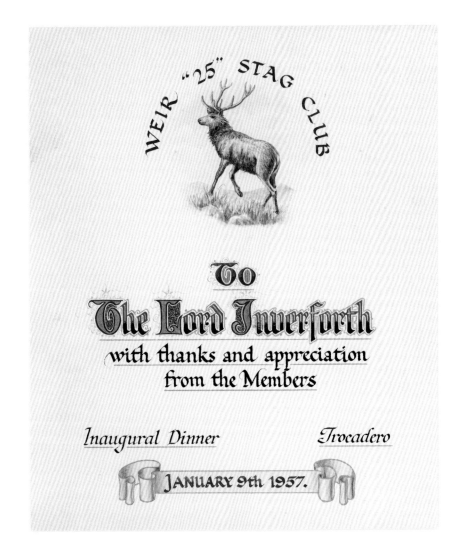

It is not clear what the Weir '25' Stag Club was. A guess would be that
it was an association of the company's employees who had served for
more than twenty-five years. The club appears to have begun in 1957,
launched with a meal at the Trocadero in Coventry Street, London,
which in 1957 was a restaurant. It was built in 1896 as a J. Lyons & Co.
restaurant. It is now an entertainment centre.

Mason
W. Bro. A.C. Morton

Alpheus Cleophas Morton PM (Past Master) was a member of the Masonic Albion Lodge No. 9 and was honoured by his fellow members for reaching fifty years of membership from 1865 to 1915. He was presented with a bright illuminated address on 2 February 1915.

While Albion Lodge No. 9 had originally been formed in 1769, it was re-consecrated in 1889. In the same year it met at the Ship and Turtle public house in Leadenhall Street, London. It now meets at Freemasons' Hall, Great Queen Street.

Page 1 and 2 of the address to W. Bro. A.C. Morton given in 1915.

The meeting to honour Morton was held at Restaurant Frascati on Oxford Street, famous for its luxury and cuisine. It had been established in the late 1890s at 32 Oxford Street. It had gold leaf decoration on the outside and a Winter Garden inside below a large glass dome. It was well known for its use of flower decorations and had a ballroom for dancing to a resident orchestra. Unfortunately, it was destroyed in the Second World War.

Alpheus Cleophas Morton had an intriguing name, although it is not clear why he was given it. He was born in 1840 and educated in Canada. He became an architect, lived in Clapham and joined the City of London Corporation in 1882. He was responsible for the opening of

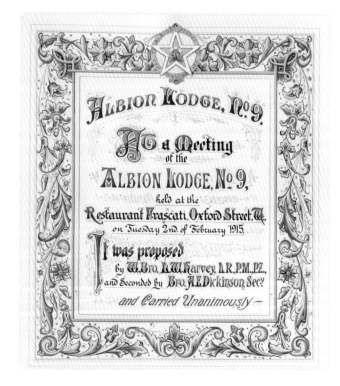

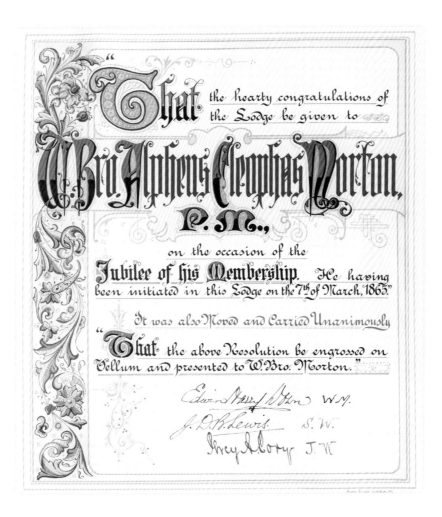

the park in Finsbury Circus and established the practice of presenting mulberries from the park to the Lord Mayor of London. Morton also saved St Dunstan-in-the-West on Fleet Street and a number of other London churches that were proposed for demolition in 1919. He was a churchwarden of St Dunstan-in-the-West.

Morton was MP for Peterborough from 1886–95 and for Sutherland from 1906–18, was knighted in 1918 and died in 1923.

Lord Mayor of Leeds
The Rt Hon. Lord Airedale of Gledhow

Lord Airedale was honoured by the High Court of the Ancient Order of Foresters in 1907. He was presented with a boxed, neat illuminated address. However, the words do not make clear what the honour was for, and the gothic words are not easy to read! It says:

... for the fraternal sympathy and hospitality extended to the representatives of the Order on the occasion of the annual meeting being held in Leeds, and, in commemoration of the fact that his honoured father was High Chief Ranger of the Order.

Perhaps he paid for the refreshments!

Gledhow sounds to me as if it should be a hamlet in the Scottish Highlands but it is, in fact, a suburb to the northeast of Leeds. Airedale is an area in Yorkshire, with the River Aire – which is more than 90 miles long – travelling through Leeds.

Within the illuminated address are two small photographs, one of the Albert Hall in Leeds and the other of Gledhow Hall. The Albert Hall began as the Mechanical Institution and Literary Society, and is now the City Museum.

Gledhow Hall was the family home of Sir James Kitson who

became 1st Baron Airedale in 1907. He was the first Lord Mayor of Leeds in 1895. Previously, Leeds had only had mayors, and much earlier an alderman, as the head of the Borough Committee. Gledhow Hall had been built in 1766 by the same architect who had designed Harewood House. The 1st Baron Airedale had made his money from iron and steel, and from making train engines.

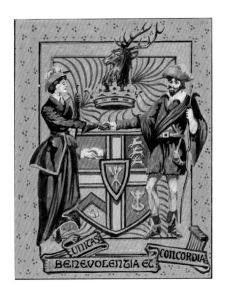

The son of the 1st Baron Airedale, Albert Kitson, inherited Gledhow Hall in 1911 when his father died, and it was used as a hospital in the First World War by the St John's Ambulance Voluntary Aid Detachment.

Albert had married Florence Schunck in 1890, the daughter of Edward von Schunck who had married Kate Lupton, whose family were well known landowners around Leeds. Edward owned the neighbouring Gledhow Wood Estate, Kate had lived at Potternewton Hall and her father, Darnton Lupton had been a Mayor of Leeds. Kate's cousin, Francis Martineau Lupton lived close by on the Newton Park Estate, whose eldest daughter Olive married Richard Noel Middleton, a solicitor. Olive and Richard are the great-grandparents of Kate Middleton, now the Duchess of Cambridge.

Olive lived at Gledhow Hall in the First World War with her second cousin, Lady Airedale, and served as a nurse with the St John's Ambulance Voluntary Aid Detachment.

The illuminated presentation to Lord Airedale was given by The Ancient Order of Foresters, a society formed in Rochdale in 1834. It was based on a reformation of the Royal Foresters Society. It is not the

Independent Order of Foresters which was created in 1874 when the North American Foresters broke away; the UK part of the Independent Order is called Forester Life.

The Ancient Order of Foresters has local branches called courts, named after the law courts of the royal forests. It is a Friendly Society offering member benefits such as discretionary grants and charitable donations.

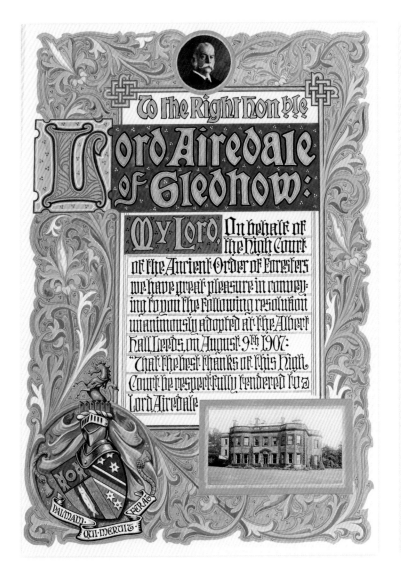

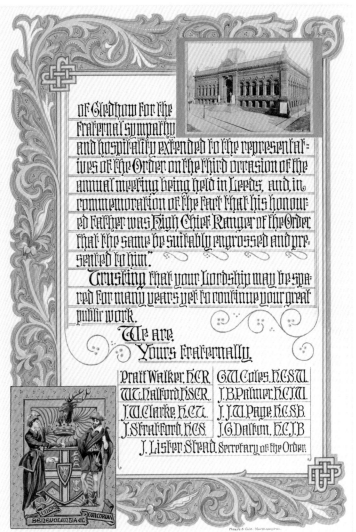

Pages 1 and 2 of the address to Rt Hon. Lord Airedale of Gledhow
given in 1907, illuminated by Hoare & Cole, Northampton.

Baronet
Lt-Gen. Sir Frederick Wellington John Fitzwygram, Bt

Many historically important families built their fame and fortune in the military or in business. One of these families, the Fitzwygrams, were involved in both.

Lt-Gen. Sir Frederick Wellington John Fitzwygram, Bt became the 4th Baronet in 1873. He was a cavalry officer with the 6th Inniskilling Dragoons, serving in the Crimean War and later in Aldershot.

The baronetcy began with Sir Robert Wigram of Walthamstow in 1805, who had started out as a ship's surgeon and then carried on to become a merchant, an owner of ships and an importer of goods from India. He was a Member of Parliament for Fowey and Wexford and a strong supporter of the Prime Minister, William Pitt. He had two wives and twenty-three children, including Robert, the 2nd Baronet. Frederick, the 4th Baronet, was a son of Robert, inheriting on his brother's death from another Robert, the 3rd Baronet. Sir Frederick changed his name to Fitzwygram in 1832, and the family name reverted back to Wigram with the 6th Baronet.

Historically, 'Fitz' meant 'son of', but sometimes it was used to denote illegitimacy.

Sir Frederick bought Leigh Park in 1875, an estate close to Portsmouth that had originally been a farm but was converted into an estate by Sir George Staunton. The estate passed to his descendants and was bought by the city of Portsmouth in 1944. The house was demolished in 1959, except for the Gothic Library

The address to Lt-Gen. Sir Frederick Fitzwygram, Bt given in 1895, illuminated by Waterlow & Sons Ltd, London.

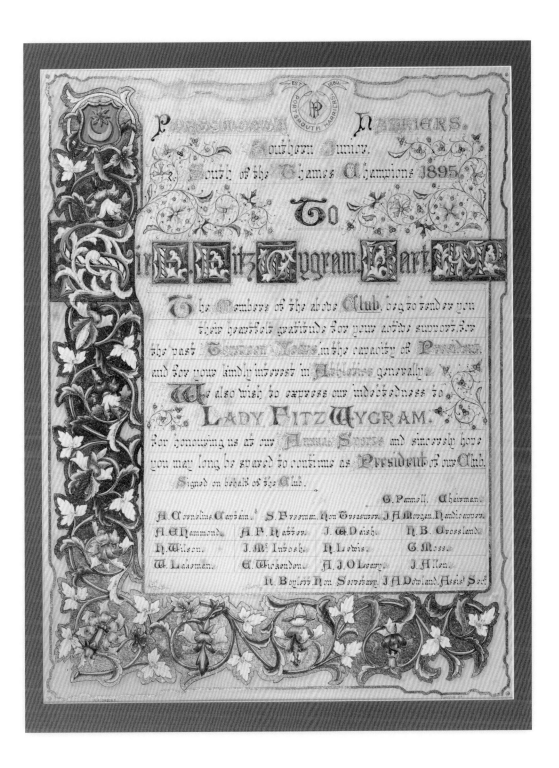

(which still exists today), and the estate was converted to one of the largest council housing estates in the country, built for the post-Second World War homeless of Portsmouth and a park, now Staunton Country Park.

Sir Frederick was very involved in public life, especially around Portsmouth, and frequently opened his grounds and gardens to the public. He was a member of the Royal College of Veterinary Surgeons and the author of *Horses and Stables*, published in 1869, which concentrated on the care of horses.

The first illuminated address, a striking picture, finely embellished in gold, was given in 1895 by the Portsmouth Harrier Athletics Club of which Sir Frederick was its president. Like many paper- and card-based items from the past, the background picture colour has turned brown. It would originally have been white.

In 1900 Sir Frederick retired as a Member of Parliament, and the constituents in the Southern Division of Hampshire presented him with a neat, colourful illuminated address in gratitude for his sixteen years of service from 1884.

The address to Lt-Gen. Sir Frederick Fitzwygram, Bt given in 1900, illuminated by A.F. Skerns, Timpson Road, Portsmouth.

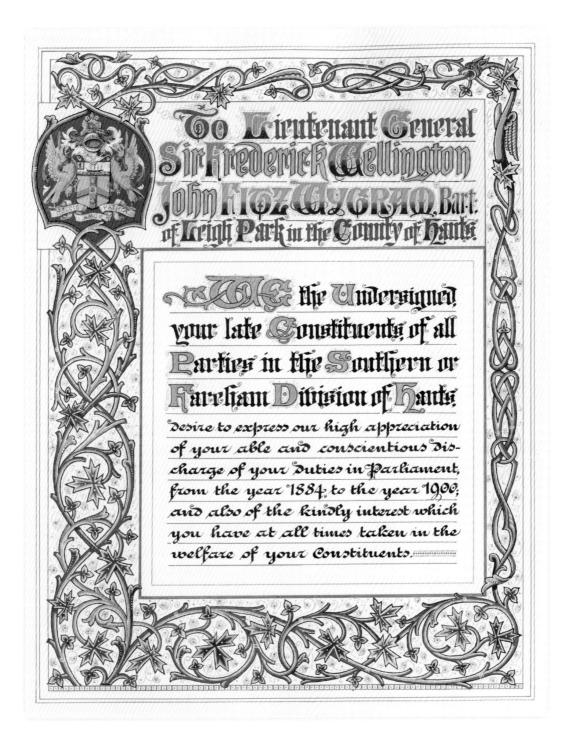

To Lieutenant General Sir Frederick Wellington John Frcz Wygram, Bart. of Leigh Park in the County of Hants.

We the Undersigned, your late Constituents, of all Parties in the Southern or Farcham Division of Hants, desire to express our high appreciation of your able and conscientious discharge of your duties in Parliament, from the year 1884 to the year 1900; and also of the kindly interest which you have at all times taken in the welfare of your Constituents.

Father and son
Matthew Fox Harrison and Frank Fox Harrison

Both father (Matthew) and son (Frank) supported the Walsall Licensed Victuallers and Beer Retailers Friendly & Protection Society.

Matthew served a phenomenal fifty-six years as the Secretary and was given his beautiful illumination in 1946 at the age of eighty-seven. He had the designated initials 'FAI' after his name, being a Fellow of the Auctioneers and Estate Agents Institute of the UK. He ran the business of Fox & Harrison, Auctioneers and Valuers in Lower Hall Lane, Walsall, first getting his auctioneers' licence in 1887. His connection with the Licensed Victuallers was as a result of managing property in Walsall, including the tenants of licensed properties.

Monogram from the address to Frank Fox Harrison.

Frank joined his father's business and also took his father's role as Secretary of the Licensed Victuallers Society. His presentation was given in 1959, also by the Licensed Victuallers Society, in celebration of him being elected as the Mayor of Walsall. Frank became a councillor in 1942, Mayor in 1958 and an alderman in 1962.

Both illuminations were superbly illustrated by the Municipal School of Art and Crafts, later known as the Walsall College of Arts and Technology. Unusually, both illuminations provide the recipients' home addresses.

Top: Page 1 and 2 of the address to Matthew Harrison given in 1946, illuminated by the Municipal School of Arts and Crafts, Goodall Street, Walsall.

Bottom: Page 1 and 2 of the address to Frank Harrison given in 1959.

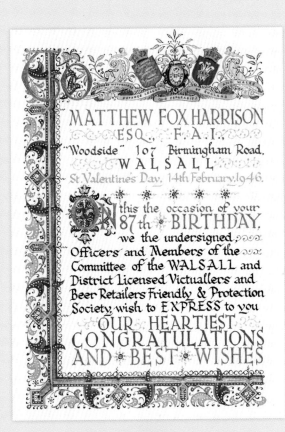

MATTHEW FOX HARRISON
ESQ., F.A.I.
"Woodside" 107 Birmingham Road,
WALSALL
St. Valentine's Day, 14th February, 1946.

ON this the occasion of your
87th BIRTHDAY,
we the undersigned
Officers and Members of the
Committee of the WALSALL and
District Licensed Victuallers and
Beer Retailers Friendly & Protection
Society wish to EXPRESS to you
OUR HEARTIEST
CONGRATULATIONS
AND BEST WISHES

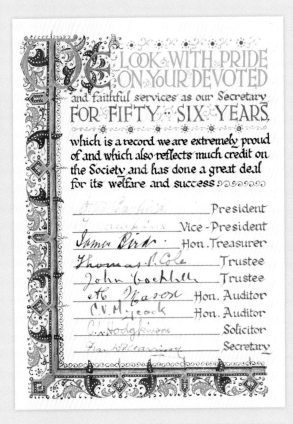

WE LOOK WITH PRIDE
ON YOUR DEVOTED
and faithful services as our Secretary
FOR FIFTY · SIX · YEARS,
which is a record we are extremely proud
of and which also reflects much credit on
the Society and has done a great deal
for its welfare and success

A. D. Parkes	President
W. Hopkins	Vice-President
James Bird	Hon. Treasurer
Thomas S. Cole	Trustee
John Cockhill	Trustee
H. Mason	Hon. Auditor
C. V. Mycock	Hon. Auditor
C. A. Hodgkinson	Solicitor
Frank Harrison	Secretary

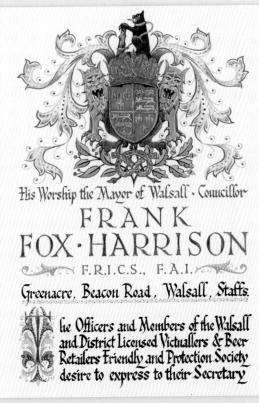

His Worship the Mayor of Walsall · Councillor
FRANK
FOX · HARRISON
F.R.I.C.S., F.A.I.
Greenacre, Beacon Road, Walsall, Staffs.

THE Officers and Members of the Walsall
and District Licensed Victuallers & Beer
Retailers Friendly and Protection Society
desire to express to their Secretary

THEIR heartiest congratulations & good wishes
on his election as Mayor of the Ancient County
Borough of Walsall for the year 1958-59.
Following the long and distinguished record
of service of his late father, with whom he
acted for many years as Assistant Secretary
and succeeded as Secretary to the Society in 1946.
We are very proud to acknowledge with sincere
thanks and appreciation his generous devotion &
kindly encouragement which have contributed so
much to the welfare and success of the Society.
HIS numerous public activities & associations
have gained the admiration & respect of the
citizens of Walsall & his elevation to the
office of the Chief Citizen of the Borough was
most worthily deserved and highly justified.
As a mark of their respect & appreciation
the members present this small token of their
esteem and sincerely trust that the Society
may be honoured with his guidance &
friendship for many years to come.

Federation president
Major Archibald Isidore Harris

Major Archibald Isidore Harris was President of the Timber Trade Federation of the UK from 1937 and was thanked for his service with a neat book when his presidency ended in 1939.

The book includes the badge of University College School (UCS), oak leaves and the motto *Paulatim*. UCS is an independent school in Hampstead and counts Sir Roger Bannister, Sir Dirk Bogarde and Sir Chris Bonington amongst its past pupils. The school's motto *Paulitim Sed Fermiter* means 'Slowly but surely'.

Major Harris (later Sir Archibald Harris) was a major in France in the First World War and was twice mentioned in despatches. He worked in the timber trade all his life. After his presidency of the Federation he served as Timber Controller in the Ministry of Trade from 1939–47.

Pages 1, 2 and 3 of the address to Major Archibald Isidore Harris given in 1939.

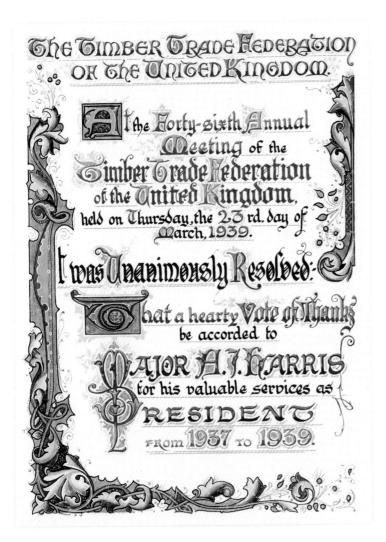

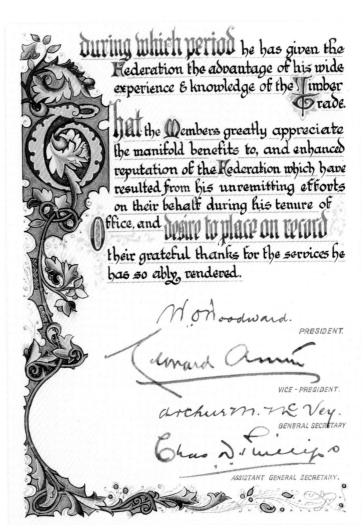

Pages 4 and 5 of the address to
Major Archibald Isidore Harris given in 1939.

University of Leeds professor
Professor Norman Mederson Comber DSc, ARCS, FRIC

In 1953 Professor Noman Mederson Comber was thanked on his retirement for his twenty-one years of service from 1932–53 as President of the Leeds University Union Agricultural Society.

He had other roles within the university, including twenty-five years on the Senate, Dean of the Faculty of Technology and Chairman of the Board of the Faculties of Science and Technology. He had academic involvement outside the university, including President of the Agricultural Section of the British Association, and was the author of *An Introduction to the Scientific Study of the Soil*, published in 1927.

Within this simple address are twenty-one typed pages of the names and addresses of staff and current and previous students, followed by their signatures. Clearly, this was a man much loved by his students, friends and colleagues. Sadly, Professor Comber died within three months of his retirement as Professor of Agricultural Chemistry and Head of the Department of Agriculture. He left a widow and two children.

Comber was brought up in Brighton and studied chemistry at the Royal College of Science in London. His first job was with the East Anglican Institute of Agriculture in Chelmsford, which got him interested in soil science. He joined the University of Leeds staff in 1913, becoming the Chair of Agricultural Chemistry in 1924. He was very active in many roles within the university and outside it, including helping to establish the Yorkshire Federation of Young Farmers' Clubs. He was also President of the Yorkshire Association of Baptist Churches.

The address to Professor Norman Mederson Comber, DSc, ARCS, FRIC given in 1953.

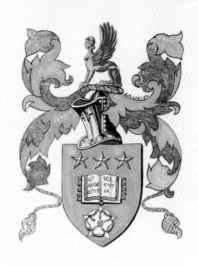

Leeds University Union Agricultural Society

to

Professor N. M. Comber

President of the Society

1932 ~ 1953

Club president
Sir John D. Laurie, TD, JP

Colonel and Alderman Sir John D. Laurie, TD, JP, was President of the City Livery Club from 1937–8. He was also a liveryman, Past Prime Warden of the Worshipful Company of Saddlers and Liveryman and Past Master of the Worshipful Company of Woolmen.

Sir John's neat illuminated address was presented to him on the termination of his office as President of the City Livery Club, together with a Past President's badge. The presentation was made by Sidney J. Fox as the first duty of the newly elected President. However, Sir John had to return the illuminated address for it to be subsequently incorporated into a bound volume of *The Liveryman*, the club's magazine.

Sir John D. Laurie.

The bound book includes five editions of the magazine from October 1937–8, the year book and the list of club members. The October 1938 edition includes both a photograph of the illumination and a write-up of the presentational speeches.

Sir John was a stockbroker, being the Senior Partner in Laurie, Millbank & Co. of Birchin Lane, London. He was alderman for the Ward of Cornhill from 1931, after the death of Sir William Waterlow, Bt. In 1935 he was Senior Sheriff of the City of London and Lord Mayor of London in 1941. His grandfather had been a sheriff in 1849, and his great uncle had been a sheriff in 1823 and Lord Mayor in 1832. Sir John was knighted in 1936.

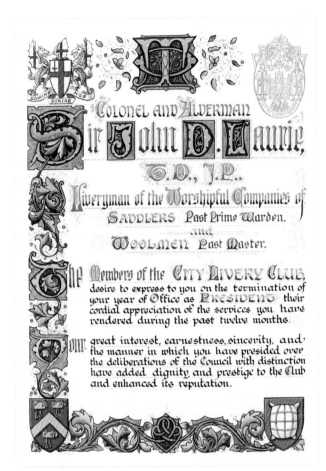

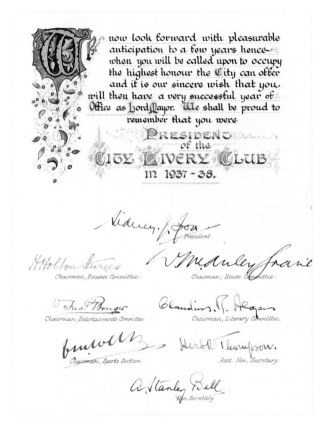

The address to Sir John D. Laurie given in 1938.

Sir John had fought in the Boer War, commanding a battalion of the West Kents, and he was mentioned in dispatches in the First World War while fighting in France and Belgium.

Sir John was a resident of Sevenoaks and was widely involved in local affairs. For twenty-one years he was a member of the Sevenoaks Urban District Council and the chairman three times. His many other roles included President of Sevenoaks and District Football League and President of Sevenoaks Football Club.

Patternmaker
William Mosses

The United Pattern Makers Association of Manchester awarded William Mosses with a colourful, professional illuminated address with fine gold highlighting and design in 1912 for his twenty-eight years of service as General Secretary.

Mosses was actually General Secretary of the United Pattern Makers Association until 1917, so it is not clear why he was given an award in 1912. Perhaps it was because the association moved its headquarters to London in that year.

Mosses was also active in the Trades Union Congress (TUC) movement. He was a member of the Parliamentary Committee twice and one of the TUC representatives at the American Federation of Labour (the American equivalent of the TUC) in 1905.

He was also the first General Secretary of the Federation of Engineering and Shipbuilding Trades from 1890.

A patternmaker makes patterns on materials. It is a skilled job, based in different industries such as clothing or metalwork. A designer outlines a pattern and the patternmaker converts the design into an object, which could be made of wood, metal, cloth or other material depending on the product. Sometimes patterns are created by making cuts into the material so that the pattern is incised. The patternmaker needs to be highly skilled in materials, design and engineering. In Mosses' time these skills would have been learned through an apprenticeship.

Page 1 of the address to William Mosses given in 1912, illuminated by Kelsall, 11 Cloisters Street, Bolton.

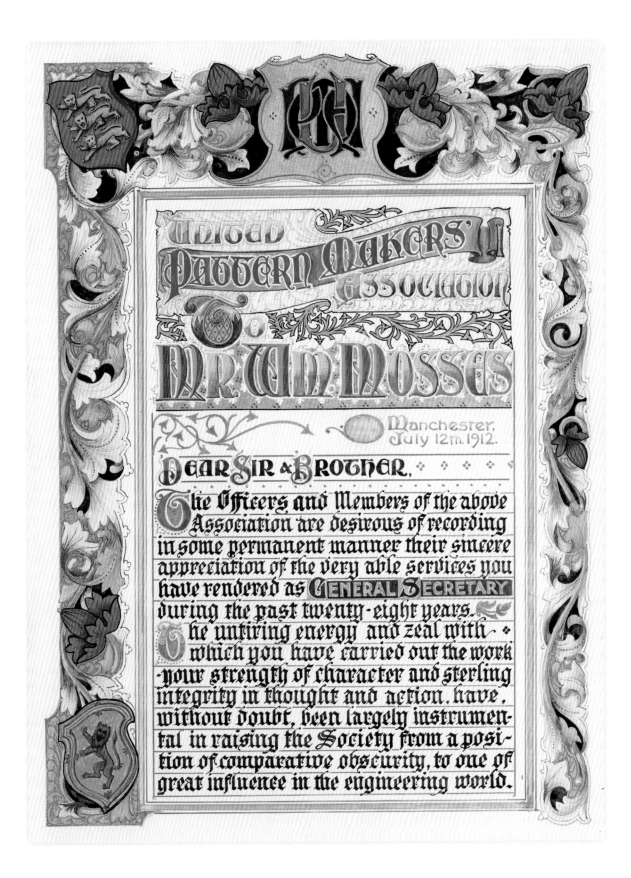

United Pattern Makers' Association

To Mr. Wm. Mosses

Manchester,
July 12th, 1912.

Dear Sir & Brother,

The Officers and Members of the above Association are desirous of recording in some permanent manner their sincere appreciation of the very able services you have rendered as General Secretary during the past twenty-eight years.

The untiring energy and zeal with which you have carried out the work - your strength of character and sterling integrity in thought and action, have, without doubt, been largely instrumental in raising the Society from a position of comparative obscurity, to one of great influence in the engineering world.

DEATH

A death in America
Eugene Van Rensselaer Thayer Jr

This illuminated address shows that illuminated presentations are not unique to the UK. The small illumination comprises of six pages of fine calligraphy embellished with neat and tasteful illuminated letters. It was produced by B.C. Kassell Co., Chicago, Illinois.

This illuminated presentation is a rare example of a sad occasion as, normally, illuminated addresses celebrate a happy event. The booklet was presented to Thayer Jr's family following his death in 1937, in recognition of his service as a director of the Terminal National Bank of Chicago. The other eleven directors of the bank are all named.

Thayer Jr was born in 1881 in Boston, Massachusetts, the son of Eugene and Susan. He married twice. His first marriage was to Gladys Baldwin Brooks in 1903, but they divorced in 1923. His second marriage was to Mary Elizabeth Harding.

Thayer Jr went to Harvard in 1904 and by 1912 had become President of the Merchants National Bank of Boston. He then became President of the Chase National Bank in New York and a director of numerous other companies, including Coca-Cola.

His ancestry appears to derive from Nathaniel Thayer who was born in Thornbury, Gloucestershire, England in 1639 and died in Braintree, Massachusetts.

The Thayer family is well represented in American history, including: Colonel Sylvanus Thayer, who established the curriculum for West Point Military Academy, is known as the Father of the Military Academy and has a monument on the campus; a number of

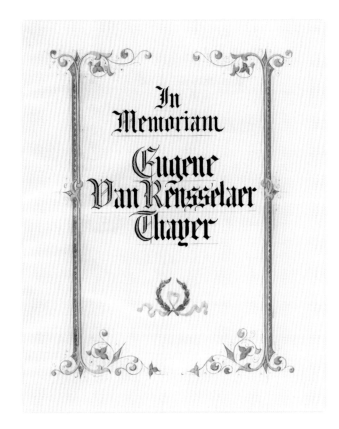

Pages 1 and 2 of the address in respect of Eugene Van Rensselaer
Thayer Jr given in 1937, illuminated by B.C. Kassell Co., Chicago.

members of the House of Representatives; William Wallace Thayer,
a Governor of Oregon; Samuel R. Thayer, US Ambassador to the
Netherlands; Edwin Pope Thayer, member as the Senate; and John
Borland Thayer and his son, Jack who were passengers on the *Titanic*.

Whereas, In His Infinite wisdom, God has removed from his family, his friends and associates,

Eugene Van Rensselaer Thayer

And Whereas, he was a distinguished and valued former member of the Board of Directors of this Bank, esteemed and beloved by his fellow directors as a man of character and integrity. In the days of stress, because of his broad and

mature experience, his high ideals and kindly personality, he contributed immeasurably to the stabilization of our Bank, and **W**hereas, in his passing, our Bank has lost a wise and sincere counsellor; his family a devoted father and husband, and the country a patriotic and philanthropic citizen; *Now, Therefore, Be it* **R**esolved, that we hereby profess admiration and affection for him and

his sterling qualities of mind and character; as well as our deep and abiding sense of loss in his passing, ❖❖❖

— And be it further —

Resolved, That this Resolution be spread at large upon the Minute Book of the Bank; and an engrossed copy delivered to his family, with sincerest expressions of sympathy and condolence.

President

Pages 3, 4 and 5 of the address in respect of
Eugene Van Rensselaer Thayer Jr given in 1937.

ESTATE OWNERS

Explorer
Henry M. Stanley

Henry M. Stanley is famous for his attributed quote 'Dr Livingstone, I presume?' Many readers may also know him as a journalist. Therefore, it may be surprising to find him included in an illuminated address list, with an address linked to his visit to the Haddo Estate, the home of Lord and Lady Aberdeen.

This large illuminated picture is more a curio than a beautiful work of art. It appears to have been presented by the tenants of the Haddo Estate, although the date is not given. Unfortunately, the ink signatures have faded over the course of time.

The picture celebrates, in elaborate language, Stanley's visit and honours his 'heroic labours in the field of African Exploration' and 'heroic career'.

Stanley was born in Wales to unmarried parents in 1841. In his early life he was known as John Rowlands and he lived with his grandfather until his death, then with other relatives and then in the poor workhouse in St Asaph, Denbighshire. When he was eighteen he went to the United States, arriving in New Orleans where he found a local trader, Henry H. Stanley, willing to employ him. They got on well and the trader became a father figure, to the point at which John Rowlands changed his name to Henry Morton Stanley. He was a soldier in the Civil War, firstly for the Confederates and later, briefly, for the Union before becoming a sailor in the Union Navy. On board, he took the role of messenger which subsequently led to his interest in being a journalist.

His journalism involved acting as a correspondent at the Indian Peace Commission, and this led to him working exclusively for the *New York Herald*. He became the *Herald*'s overseas correspondent and was sent in

The address to
Henry M. Stanley.

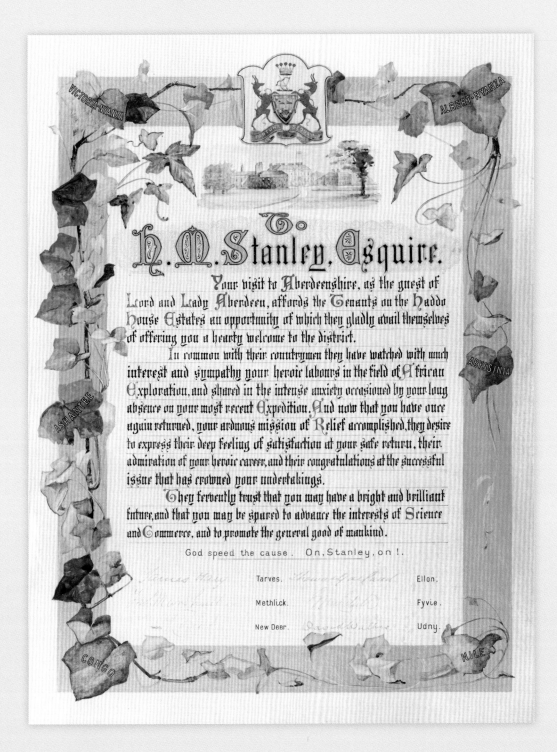

To H. M. Stanley, Esquire.

Your visit to Aberdeenshire, as the guest of Lord and Lady Aberdeen, affords the Tenants on the Haddo House Estates an opportunity of which they gladly avail themselves of offering you a hearty welcome to the district.

In common with their countrymen they have watched with much interest and sympathy your heroic labours in the field of African Exploration, and shared in the intense anxiety occasioned by your long absence on your most recent Expedition. And now that you have once again returned, your arduous mission of Relief accomplished, they desire to express their deep feeling of satisfaction at your safe return, their admiration of your heroic career, and their congratulations at the successful issue that has crowned your undertakings.

They fervently trust that you may have a bright and brilliant future, and that you may be spared to advance the interests of Science and Commerce, and to promote the general good of mankind.

God speed the cause. On, Stanley, on!.

	Tarves.		Ellon.
	Methlick.		Fyvie.
	New Deer.		Udny.

1869 to find Dr David Livingstone. He travelled to Zanzibar in 1871 to collect provisions for his exploration. He found Dr Livingstone in late 1871 near Lake Tanganyika. The greeting 'Dr Livingstone, I presume?' is not corroborated by reports, and is likely to have been created editorially later for publication in the *New York Herald*.

David Livingstone was born in 1813 in Scotland and is famous for having been a doctor, missionary and explorer. His exploits were popular with the public. He was keen to find the source of the Nile, as he thought it would give him valuable influence in his missionary work. While in Africa he lost contact with the outside world for six years, until found by Stanley. He died in Africa.

Lord Aberdeen, referred to in the address, is likely to have been John Campbell Hamilton-Gordon, 1st Marquess of Aberdeen and Temair, and the 7th Earl of Aberdeen. He was a politician, Lord Lieutenant of Ireland and Governor General of Canada. His father had been the 5th Earl, who died in 1864, and his older brother had been the 6th Earl until his death in 1870. Lady Aberdeen was Ishbel Maria Marjoribanks, daughter to Sir Dudley Marjoribanks, the 1st Baron Tweedmouth.

The 4th Earl, who also had lived on the Haddo Estate, was the British Prime Minister from 1852–5. The Haddo Estate is now owned by the National Trust for Scotland.

A well-connected family
The Hon. Charles Forbes-Trefusis

Here there are two illuminated scrolls for The Hon. Charles Forbes-Trefusis.

The first illuminated scroll was given to The Hon. Charles Forbes-Trefusis of Pitsligo, Fettercairn and Invermay, in Scotland by the tenants, feuars and other residents of New Pitsligo in 1884 on attaining his majority. Feuars is a Scottish word for people who use land in return for a fee or service, with a similar usage as feudal.

The Hon. Charles John Robert Hepburn-Stuart-Forbes-Trefusis was the son of the 20th Baron Clinton and succeeded to the title in 1904. He had many roles, including Keeper of the Privy Seal of the Duchy of Cornwall, Lord Warden of the Stannaries, Joint Parliamentary Secretary to the Board of Agriculture and Fisheries, Chairman of the Forestry Commission and a director of Southern Railways.

Forbes-Trefusis's mother was Harriet Forbes, daughter of Sir John Stuart Hepburn Forbes, 8th Baronet of Monymusk, Fettercairn and Pitsligo. His maternal and paternal grandmothers were related, being sisters Elizabeth and Harriett Kerr.

Forbes-Trefusis was married to Lady Jane McDonnell, daughter and one of the ten children of Mark McDonnell, the 5th Earl of Antrim. Mark McDowell was the son of Lord Mark Kerr, a descendant of the Marquess of Lothian and Charlotte McDonnell, the Countess of Antrim.

The second illuminated scroll was given to Forbes-Trefusis in 1885 in gratitude for standing in the General Election on behalf of the Unionists of Kincardineshire.

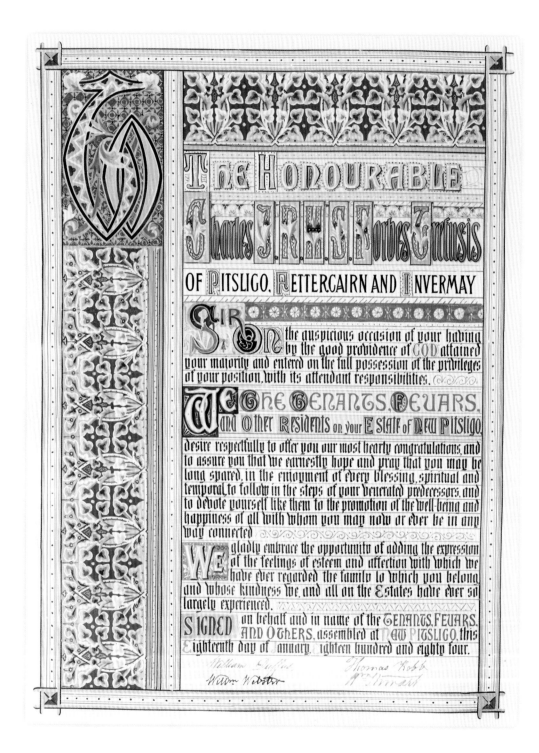

He inherited the 55,000 acres of the Rolle estates in Devon, in 1907, including Stevenstone House in Great Torrington, the grand family home of the Rolle family. Forbes-Trefusis inherited the estates form his uncle Mark Rolle, who had inherited the estates from his uncle and aunt, John Rolle, 1st Baron Rolle and his wife Louisa who had been Louisa Trefusis before marriage, daughter of an earlier Baron Clinton. Forbes-Trefusis sold Stevenstone in 1912 to Captain John Oliver Clemson and his wife Mary. The captain died at Gallipoli in 1915 and Mary remarried.

Stevenstone was auctioned twice, in 1930 and 1931, and the estate was sold in pieces and gradually demolished. Stevenstone's library still stands and can be rented for holidays from the Landmark Trust.

The Hon. Charles Forbes-Trefusis, 21st Baron Clinton, had two daughters. One, the Hon. Fenella Hepburn Stuart Forbes-Trefusis married the Hon. John Herbert Bowes-Lyon, the son of the 14th Earl of Strathmore and Kinghorne and brother to Elizabeth Bowes-Lyon, who became Queen Elizabeth, mother to Queen Elizabeth II.

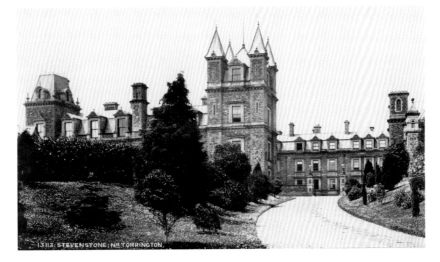

Stevenstone House.

The address to the Hon. Charles Forbes-Trefusis given in 1884.

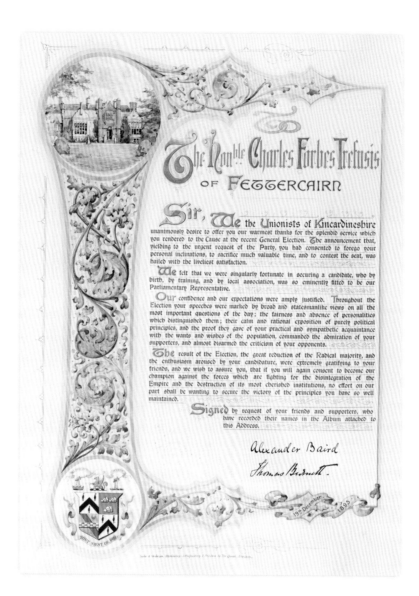

The aaddress to the Hon. Charles Forbes-Trefusis given in 1885, illuminated by Taylor & Henderson, Aberdeen.

If you are a folk dance enthusiast you may recognise the name Trefusis. There is a Trefusis Hall within Cecil Sharp House in London named after Lady Mary Hepburn Stuart Forbes-Trefusis (sister-in-law to Forbes-Trefusis). Cecil Sharp House is the home of the English Folk Dance Society and Lady Mary was their President from 1913 until her death in 1927.

Brewer
Robert Blezard

Robert Blezard lived at Pool Park in Ruthin, Denbighshire, North Wales. His son George celebrated his twenty-first birthday in 1876 and the residents of Ruthin took the opportunity to congratulate Blezard for his son attaining the age of majority with the presentation of a single page, rather formal address with gold embellishing. They did so because the Blezard family provided employment and support for the community.

Pool Park is on the site of one of the deer parks of Ruthin Castle. The estate was in the ownership of the Salesbury family until it passed by marriage to the Bagot family in 1670. The story goes that Sir Walter Bagot's spaniel strayed on to Jane Salesbury's land and he instantly fell in love with Jane, who was a wealthy heiress. Their marriage took place in secret and Jane's cousin William spent the rest of his life contesting Jane's inheritance, without success.

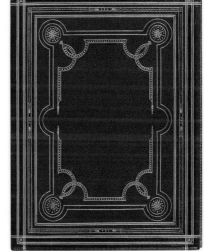

The cover of the illuminated folder.

The estate remained in the Bagot family and the house was rebuilt in 1826. Later in the nineteenth century the estate was let out. George Richards Elkington, who pioneered electroplating, was a tenant, and died there in 1865. Later Blezard, a brewer, took the tenancy. Robert and George both bred a herd of shorthorn cows on the estate. George died there in 1907.

In 1928 Pool Park was lost to the Bagot family on a bet at the races and the estate was put on the market. The parkland was sold to a timber merchant and some of the tenant farmers bought their farms.

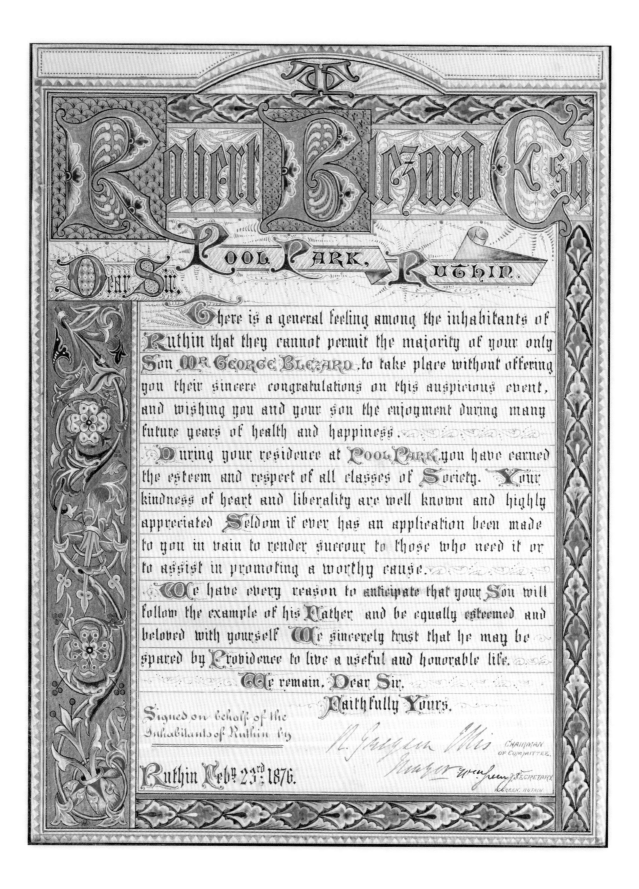

The house was leased to Sir Ernest Tate, 3rd Baronet, as a retreat. Sir Ernest Tate was the grandson of Sir Henry Tate, 1st Baronet, of Tate & Lyle, the sugar manufacturer. Sir Henry Tate had created a sugar refining business in Liverpool in 1859, and it expanded into East London, based at Silvertown, in 1878. On his death in 1899 he donated his collection of paintings to the nation, now held in the Tate Gallery.

In 1934 Pool Park was converted to a convalescent home. The grounds were used as a prisoner of war camp during the Second World War. After the war the house became a mental hospital until 1989. It was sold in 1992 and has remained empty ever since.

The address to Robert Blezard given in 1876, illuminated by W. Green, Ruthin.

An inheritance
William Egerton Garnett-Botfield

William Egerton Garnett-Botfield was given a large, impressive folder housing an illuminated address by the tenants of his father's estate, Decker Hall, Shifnal in Shropshire on the occasion of his marriage.

The illuminated address is undated and his wife is not named, but we know from other sources that he married Elizabeth Clulow Howard-McLean of Aston Hall in 1881.

Garnett-Botfield was the eldest son and one of six children born in 1849 to the Rev. William Bishton Garnett-Botfield and his wife Sarah Dutton. He was born in Findon, Sussex. His father inherited an estate and fortune in 1863, and took the name Botfield by Royal Licence.

Garnett-Botfield had three children. He was a magistrate, councillor, alderman and mayor, and gave much support to local schools. He died at The Hut, Bishop's Castle in Shropshire in 1906.

Cover of the illuminated address.

Page 1 of the address to William Egerton Garnett-Botfield, most likely given in 1911, illuminated by Adnitt & Naunton, Salop.

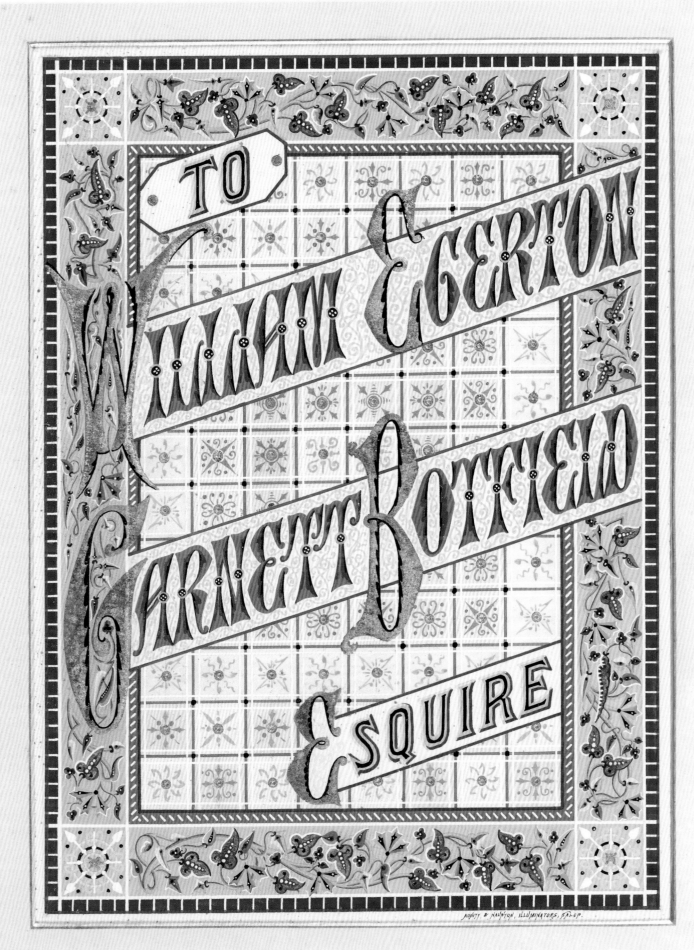

TO
WILLIAM EGERTON
GARNETT BOTFIELD
ESQUIRE

ADNITT & NAUNTON, ILLUMINATORS, SALOP.

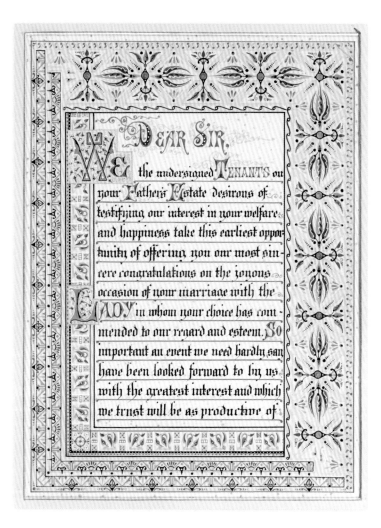

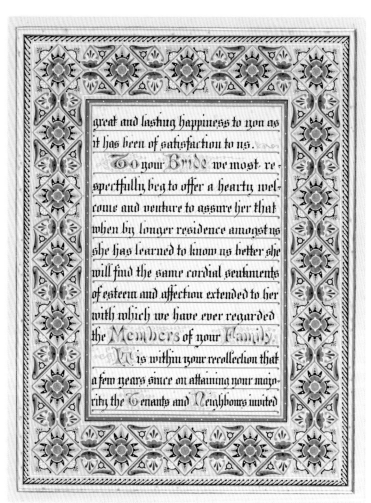

Pages 2 and 3 of the address to William Egerton
Garnett-Botfield, most likely given in 1911.

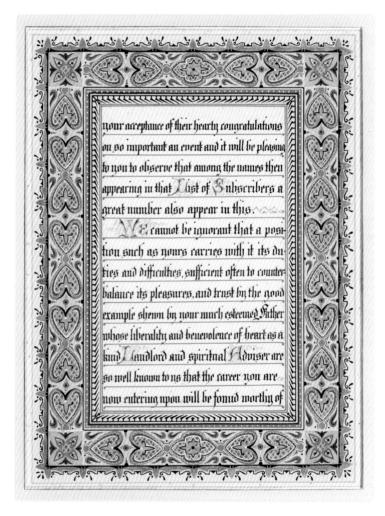

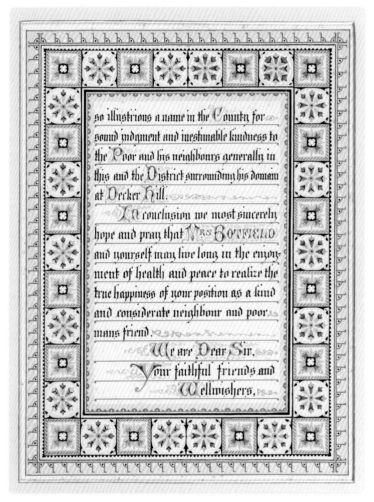

your acceptance of their hearty congratulations on so important an event and it will be pleasing to you to observe that among the names then appearing in that List of Subscribers a great number also appear in this.

We cannot be ignorant that a position such as yours carries with it its duties and difficulties, sufficient often to counterbalance its pleasures, and trust by the good example shewn by your much esteemed Father whose liberality and benevolence of heart as a kind Landlord and spiritual Adviser are so well known to us that the career you are now entering upon will be found worthy of

so illustrious a name in the County for sound judgment and inestimable kindness to the Poor and his neighbours generally in this and the District surrounding his domain at Decker Hill.

In conclusion we most sincerely hope and pray that Mrs Botfield and yourself may live long, in the enjoyment of health and peace to realize the true happiness of your position as a kind and considerate neighbour and poor mans friend.

We are Dear Sir,
Your faithful friends and
Wellwishers,

Pages 4 and 5 of the address to William Egerton
Garnett-Botfield, most likely given in 1911.

Marriage in Daventry
Mr and Mrs Herbert Mountain

It is a unique gift to give an original illuminated presentation. The members of the Christian Endeavour Society in Daventry presented both a tea service and a small, humble booklet housing the illuminated address when Herbert Mountain married Miss Simpson to become Mr and Mrs Mountain in June 1912. It is pleasing to see ordinary, as well as titled, people receiving an illuminated address.

This is a short and simple but very effective modern-looking design in the Art Nouveau style, which had developed in the late 1800s, taking its design from the natural shape of flowers and plants and using whiplash lines. These are evident in the colourful surrounds to the text.

I had wondered whether Herbert's parents had been influenced by the early nineteenth-century polar expeditions in naming their son, as the Herbert Mountains are a mountain range in Antarctica, but this was not the case. The Herbert Mountains were named in 1957 after being identified by an expedition led by Sir Edwin Herbert.

The address to Mr and Mrs Herbert Mountain given in 1912.

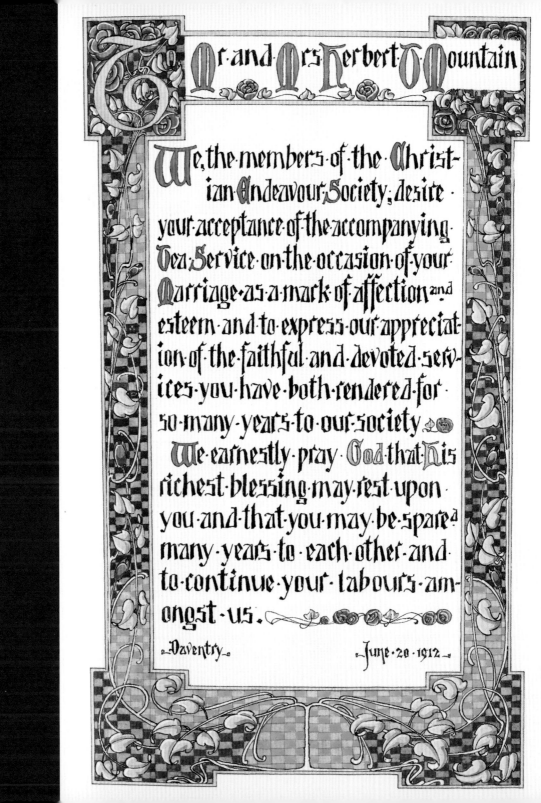

To Mr and Mrs Herbert Mountain

We, the members of the Christian Endeavour Society, desire your acceptance of the accompanying Tea Service on the occasion of your Marriage as a mark of affection and esteem and to express our appreciation of the faithful and devoted services you have both rendered for so many years to our society.

We earnestly pray God that His richest blessing may rest upon you and that you may be spared many years to each other and to continue your labours amongst us.

Daventry

June 20 1912

Wedding
Miss Phoebe Mary Vlieland

It is sometimes difficult to remember the details of one's wedding day and, in particular, the gifts received, but some gifts are so special or unusual that they are unlikely to be forgotten.

Miss Phoebe Vlieland was given a special, beautiful gift when she married Dudley Batty in June 1912 in Exeter. The gift was a vibrant illuminated folder given by the Justices of the Peace, aldermen, councillors, governors of the Royal Albert Memorial, members of the

Exeter Education Committee and other City of Exeter officials, as Phoebe's father, Charles James Vlieland, had been the Mayor of Exeter in 1911. Exeter is unusual, as it was the first English town to appoint a mayor. All the officials had contributed towards the gifts, which included a silver tray and a brooch. Two of the list of officials were Sidney Snodgrass and Thomas Tickle!

Phoebe Vlieland was from quite a comfortable family. Her father was a doctor, she had three siblings and the family was looked after by three servants.

The name Vlieland, I have assumed, derives from the place Vlieland (pronounced Vlilant), an island in the Netherlands. It is one of a string of islands between the North Sea and the mainland, due north of Amsterdam. It is a little populated island, having only one village, and consists mainly of sand dunes and is usually very windy. Phoebe's great-grandfather was Dutch.

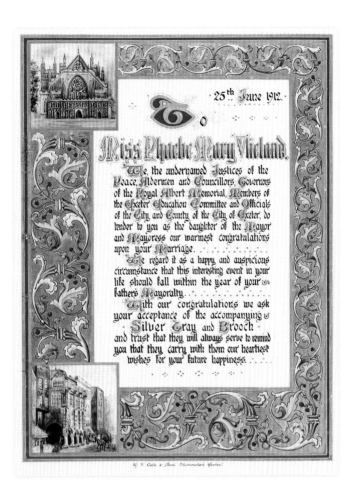

The address to Phoebe
Vlieland given in 1912,
illuminated by W.V.
Cole & Sons, Exeter.

Phoebe's husband was fifteen years her senior. He was a mechanical
engineer who worked in later life for AEI (Associated Electrical
Industries), an innovative scientific company. Dudley and his brother
visited Australia in 1894 where he inherited his aunt's estate. It
appears he was comparatively well-off. After Phoebe and Dudley's
marriage in June 1912, they settled in South Kensington, where they
had one child, Aubrey. Unfortunately, she lived only a few hours.
Phoebe and Dudley moved to a house called Upalong in Gerrards
Cross where they remained. Dudley died in 1933 at the age of sixty
and Phoebe in 1980 at the age of ninety-two.

ROYALTY

Duke
The Duke of Connaught

What must it be like being one of nine children? Being part of a large family was a far more common occurrence in Victorian times than now. The Duke of Connaught was brought up in Windsor Castle, lost his father as a child and was lined up for marriage with a princess for political alliance reasons. Further, he was part of a family with siblings squabbling over their spouses' countries of origin.

HRH Prince Arthur William Patrick Albert was born at Buckingham Palace in 1850, the seventh of Queen Victoria's nine children. He was named Arthur after the Duke of Wellington. He followed a military career and served in South Africa, Canada, Egypt and India, and rose to the rank of Field Marshal. He gained his title as Duke of Connaught and Strathearn in 1874 and also became the Earl of Sussex. He was entitled to become the Duke of Saxe-Coburg and Gotha after the death of his elder brother's son, Prince Alfred of Edinburgh in 1899, but renounced the right.

The prince married Princess Louise Margaret of Prussia and they lived in Bagshot Park, in Windsor Great Park, the current home of Prince Edward, Earl of Wessex and the Countess of Wessex. They had three children. The first child, Princess Margaret, married the Crown Prince of Sweden and had five children, including Ingrid who became the Queen of Denmark and was mother to King Carl XVI Gustaf of Sweden, Queen Margrethe of Denmark and Queen Anne-Marie of Greece.

The address to the Duke of Connaught given in 1883.

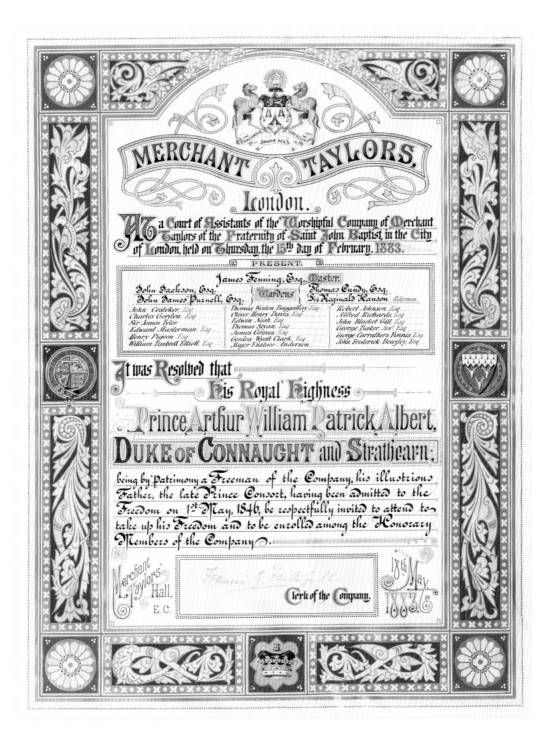

MERCHANT TAYLORS.

London.

At a Court of Assistants of the Worshipful Company of Merchant Taylors of the Fraternity of Saint John Baptist, in the City of London, held on Thursday, the 15th day of February, 1883.

PRESENT.

James Fenning, Esq., *Master.*

Wardens

John Jackson, Esq. Thomas Cundy, Esq.
John James Purnell, Esq. Sir Reginald Hanson, *Alderman*

John Costeker, Esq.	Thomas Weston Baggallay, Esq.	Robert Johnson, Esq.
Charles Gordon, Esq.	Oliver Henry Davis, Esq.	Alfred Richards, Esq.
Sir James Tyler	Edwin Nash, Esq.	John Blacket Gill, Esq.
Edward Masterman, Esq.	Thomas Sivan, Esq.	George Baker Jun.r Esq.
Henry Pigeon, Esq.	James Graves, Esq.	George Carruthers Finnis, Esq.
William Pimbrell Elliott, Esq.	Gordon Wyatt Clark, Esq.	John Frederick Beazley, Esq.
	Major Eustace Anderson	

It was Resolved that

His Royal Highness

Prince Arthur William Patrick Albert,

DUKE of CONNAUGHT and Strathearn,

being by Patrimony a Freeman of the Company, his illustrious Father, the late Prince Consort, having been admitted to the Freedom on 1st May, 1846, be respectfully invited to attend to take up his Freedom and to be enrolled among the Honorary Members of the Company.

Merchant Taylors' Hall, E.C.

Francis G. Faithfull
Clerk of the Company.

18th May 1883.

The heading of another address to the Duke of Connaught in fine illuminated lettering.

The Duke and Duchess of Connaught spent time in Canada where Prince Arthur was Governor General from 1911–16. Princess Louise died in 1917 and their daughter Princess Margaret died in 1920 whilst pregnant with her sixth child. The prince also outlived his second child, Prince Arthur, who died in 1942. The title of Duke of Connaught passed to his grandson Alastair, who died aged twenty-nine in 1943 on active service without a successor, so the title ceased.

HRH Prince Arthur William Patrick Albert Duke of Connaught and Strathearn was invited to be admitted to be enrolled as an Honorary Member of the Company of Merchant Taylors in 1883, and was given an attractive illumination to recognise this. His father, Prince Albert, had been similarly invited in 1846.

Connaught is in the west of Ireland (now renamed Connacht) and Strathearn is in Scotland.

Princess
Princess Christian of Schleswig-Holstein

The members of the royal family in Victorian and Edwardian times were probably given more illuminated presentations than anyone else. A presentation address is likely to have been given for many reasons: for a royal visit, perhaps to open a municipal building or possibly in gratitude for being a patron for a charity.

A typical, but impressive, scroll presentation was given to Princess Christian of Schleswig-Holstein in 1904 in celebration of her visit to the Royal Women's Guild of South Africa. The presentation is in private hands and I suspect that there were, and still are, too many gifts given to the royal family to be retained.

Princess Christian is liable to have gone to South Africa to visit the grave of her son, Prince Christian Victor, who had died in 1900 in the Second Boer War.

Princess Christian was born in 1846 at Buckingham Palace as HRH the Princess Helena, the fifth child of Queen Victoria and a sister to the Duke of Connaught. In 1860, when Prince Albert died, she moved with her mother and the rest of the family from Windsor Castle to Osborne House on the Isle of Wight. Helena was romantically involved with Prince Albert's librarian until he was dismissed by Queen Victoria. She welcomed and married her third cousin Prince Christian of Schleswig Holstein in 1866 at Windsor Castle, who was fifteen years her senior. As is the custom of a woman marrying a prince who has not received a peerage, she adopted her husband's Christian name as her own. They lived in Cumberland Lodge in Windsor Great Park, close to Queen Victoria. The prince had come initially to England at the request of Queen Victoria in the

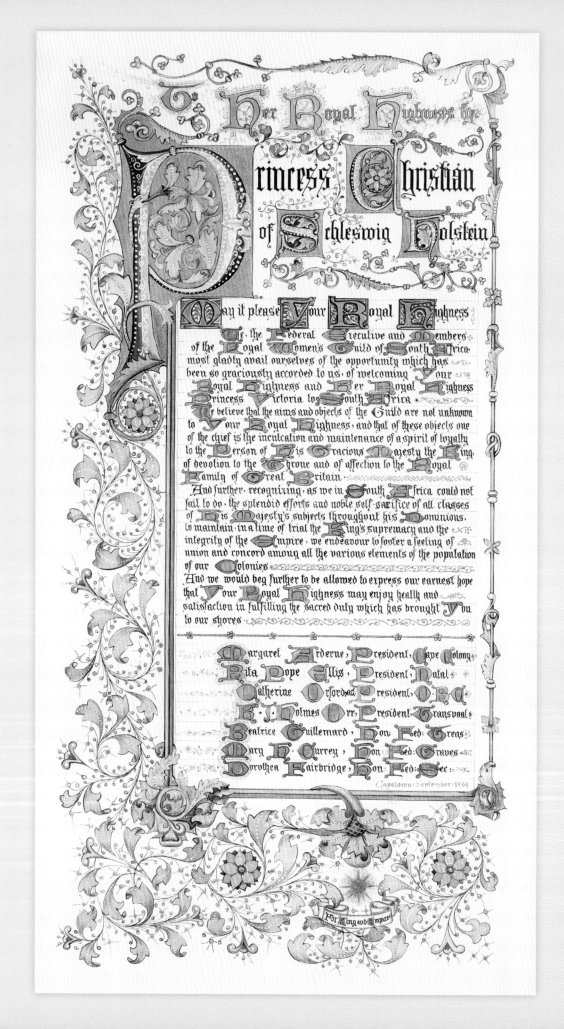

assumption that he was to be a potential new husband for her, rather than her daughter.

The marriage caused a rift in her family, as Schleswig and Holstein were fought over in the Schleswig Wars (in which Prussia and Austria defeated Denmark) and the Austro-Prussian War (in which Prussia defeated Austria). Alexandra, wife of the Prince of Wales and daughter of the King of Denmark (and also a third cousin to Prince Christian) supported Denmark's claim to Schleswig and Holstein. Princess Alice, Queen Victoria's second eldest daughter, also opposed the marriage. However, Queen Victoria and her eldest daughter Victoria, who was a personal friend of Prince Christian's family, supported the prince's claim and the marriage.

The couple had six children, although two did not live long, and led a relatively quiet and happy life. Princess Christian worked for her mother as a junior secretary. She suffered health problems and was addicted to opium and laudanum. She was very active in royal engagements and charities, being a founding member of the Red Cross. Prince Christian died in 1917 and she in 1923.

The address to Princess Christian of Schleswig-Holstein given in 1904, illuminated in Capetown.

Prince
The Prince of Teck

Each senior member of our present royal family undertakes a large number of engagements every year. Most are likely to be goodwill visits, perhaps to open a new building or to celebrate an anniversary. It is also likely that there will be a gift of some kind, given in thanks.

Past royalty also had this role and illuminated presentations were commonly used for gifts.

One example is a folder given to the Prince of Teck in 1870 for attending the festival to celebrate the fifty-fifth anniversary of the Royal Caledonian Asylum in Holloway.

In 1870 the asylum was situated on the Caledonian Road, London, a road that begins near King's Cross and heads north. The asylum had been founded earlier in the century, based in Islington. In the early 1900s it moved to Bushy, Hertfordshire, now the home of the Purcell School of Music.

For most of its existence, the asylum was a charity for the education and support of the children of Scottish servicemen and the orphans of Scottish Londoners. The proceeds of the sale to the Purcell School of Music were used to fund the Royal Caledonian Education Trust, to continue the charity's aims.

The Prince of Teck was Queen Mary's father, Queen Mary being the wife of King George V.

The Prince of Teck was born in Slavonia, now part of Croatia, as Francis, Duke of Teck, the son of Duke Alexander of Württemberg

The address to the Prince
of Teck given in 1870.

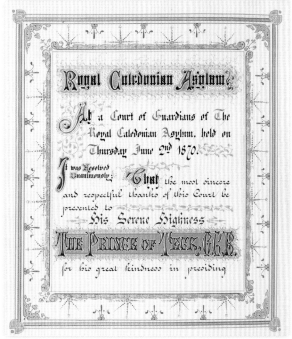

and Countess Claudine von Rhédey von Kis-Rhéde. He became an officer in the Austrian army and was created the Prince of Teck in the Kingdom of Württemberg in 1863. He left the army when he married Princess Mary Adelaide of Cambridge in 1866, the younger daughter of Prince Adolphus, Duke of Cambridge, and a granddaughter of King George III and a cousin of Queen Victoria. They lived in Kensington Palace and White Lodge in Richmond Park. They had one daughter, Princess Victoria Mary Augusta Louise Olga Pauline Claudine Agnes of Teck, and three sons.

Princess Victoria Mary was initially engaged to Prince Albert Victor, Duke of Clarence, son of the Prince and Princess of Wales (later King Edward VII and his wife Queen Alexandra), but he died a few weeks later of the influenza pandemic. Instead, the princess married Prince Albert's brother, Prince George, Duke of York. Therefore, she became Queen Mary and Empress of India. She died in 1953 at the beginning of the reign of her granddaughter, Queen Elizabeth II.

The Prince of Teck died in 1900 at White Lodge.

Visit by a princess
Princess Alice, Countess of Athlone

Princess Alice was born in Windsor Castle in 1883. She was named Alice Mary Victoria Augusta Pauline, with the title Her Royal Highness Princess Alice of Albany. She also received the titles Princess of Saxe-Coburg and Gotha, and the Duchess of Saxony. She was born to Prince Leopold, Duke of Albany (the youngest son of Queen Victoria) and Princess Helena of Waldeck and Pyrmont. Queen Victoria was one of her godmothers.

Princess Alice had a younger brother, Prince Charles Edward, but unfortunately Prince Leopold died before his son's birth. Prince Charles Edward studied in Bonn and became close to Kaiser Wilhelm II. When the First World War began, he became a general in the German army and his British titles were removed in 1919. He later joined the Nazi Party and his three sons fought for Germany in the Second World War. He was imprisoned after the war and his sister, Princess Alice, visited Germany to plead, unsuccessfully, for his release.

Princess Alice was married at Windsor in 1904 to Prince Alexander of Teck, the brother of Princess Mary, the Princess of Wales, who married King George V and became Queen Mary. On her marriage, Princess Alice became HRH Princess Alexander of Teck. She had three children but one died in infancy. She was a haemophilia gene carrier, inherited from her father.

In 1917 all Germanic titles were changed, and Prince Alexander of Teck took the surname Cambridge and became, briefly, Lord Cambridge and then the Earl of Athlone. In 1924 he was appointed the Governor General of South Africa, with Princess Alice becoming the vicereine. Lord Athlone and Princess Alice returned to England in 1931.

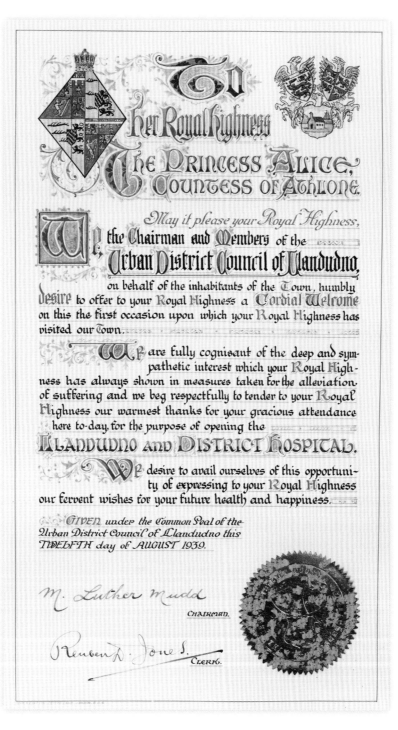

In 1939 Princess Alice visited Llandudno to open a hospital and was presented with a pretty illuminated scroll by the Chairman and Urban District Council of Llandudno.

Lord Athlone became Governor General of Canada from 1940–46, with Princess Alice becoming a vicereine once again. When in England, Lord Athlone and Princess Alice lived at Kensington Palace, where Lord Athlone died in 1957. Princess Alice died in 1981 at the age of ninety-seven, the last grandchild of Queen Victoria and the longest-lived British princess by descent.

The address to Princess Alice, Countess of Athlone given in 1939, illuminated by Shaw & Sons, Fetter Lane, London

SPORT

Footballer
James W. Lewis

Football has significantly changed over the years. The top professional players are very well paid and the teams have many international players and managers. What a different situation to that in place only a few years ago!

James (Jim) Lewis Sr was a footballer from a different age, a time when there were many amateurs who played the sport in addition to their normal day jobs. Jim was a toy shop owner as well as a keen amateur footballer playing for Walthamstow Avenue, one of the best amateur teams in the country. He also played for his country, participated in 120 matches and was recognised for his great contribution by the Football Association in 1942 with a stylish illuminated presentation.

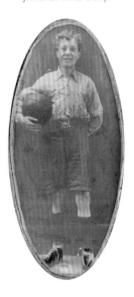

James Lewis as a boy.

Jim had two sons: the older was also named Jim, who also joined Walthamstow aged sixteen in 1943. Jim Sr and Jim Jr played together until the latter was sent on National Service to India. On his return, he re-joined Walthamstow which won the FA Amateur Cup in 1952 at Wembley in front of 100,000 people. In the next season Walthamstow went out in the fourth round of the FA Cup, playing Manchester United, Jim Jr having scored three goals. He was signed by the Chelsea Manager, Ted Drake, in late 1952. Jim Jr refused to turn professional. He worked as a travelling salesman for Thermos flasks and earned more as a salesman – £20 a week – than he could earn as a footballer, and he got a car. Few footballers could afford such a luxury. His employer was generous with time off to train and play. Chelsea won the First Division league title in 1954–5. He also played for Great Britain in the 1952 (Helsinki), 1956 (Melbourne) and 1960 (Rome) Olympics.

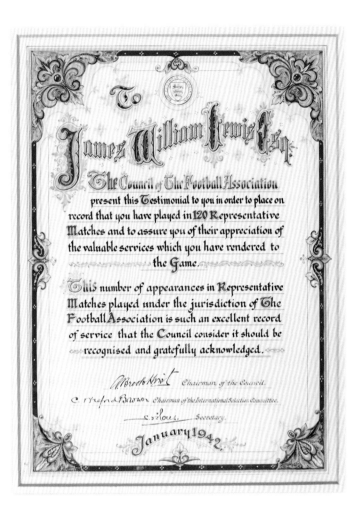

The address to James Lewis given in 1942.

Amateur status was removed by the Football Association in 1974 because of the frequency of secret payments to amateurs. In 2005 Jim Jr was invited back to Chelsea when the team won the Premier title, fifty years after its first success.

Walthamstow Avenue Football Club ceased to exist in 1988 when it merged with Leytonstone, which then became Redbridge Forest, and subsequently Dagenham and Redbridge.

Football club
Oxford City Football Club

The manner in which football leagues are organised, especially those below the top four divisions (the Football League), can be confusing. Below this is the National League, which is comprised of seven groups or steps. The rest is too complicated to describe here!

Oxford City Football Club was formed in 1882. The club reached the finals of the Amateur Cup Competition three times between 1902 and 1913, winning the cup once in 1906 and being runners-up twice. It joined the Isthmian League in 1907. The club had eight players who gained international caps. Despite its early success, the club declined over the twentieth century. The Football Association Council gave Oxford City Football Club a colourful, charming illuminated certificate in 1958 in celebration of its anniversary of existence for seventy-five years.

In 1979 there was an effort to reverse the decline of the club when it became a limited company. Bobby Moore became its manager with Harry Redknapp his assistant manager. In 1988 the club lost its grounds and it was forced to resign from the Isthmian League. In 1990 it joined the South Midlands League Division One and won promotion, returning to the Isthmian League in 1993 and moving to its current ground in Marsh Lane Marston, near Oxford.

Oxford City is not to be confused with the more successful Oxford United, which began as Headington United in 1893, changed its name in 1960, entered the Football League in 1962 and won the League Cup in 1986.

The address to Oxford City Football Club in 1958, illuminated by C.W. Harris, 28 King Street, London.

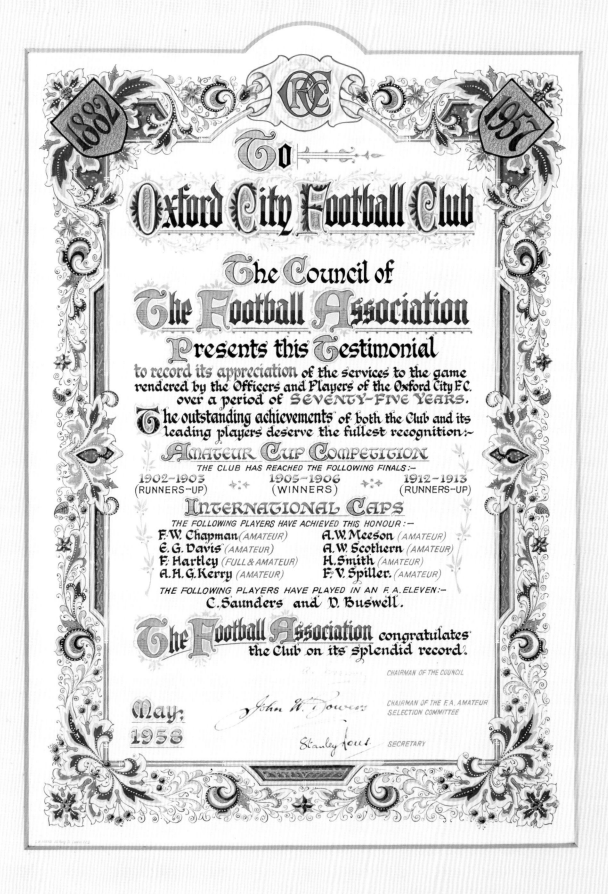

To

Oxford City Football Club

The Council of

The Football Association

Presents this Testimonial

to record its appreciation of the services to the game
rendered by the Officers and Players of the Oxford City F.C.
over a period of SEVENTY-FIVE YEARS.
The outstanding achievements of both the Club and its
leading players deserve the fullest recognition:-

AMATEUR CUP COMPETITION

THE CLUB HAS REACHED THE FOLLOWING FINALS:-

1902–1903	1905–1906	1912–1913
(RUNNERS–UP)	(WINNERS)	(RUNNERS–UP)

INTERNATIONAL CAPS

THE FOLLOWING PLAYERS HAVE ACHIEVED THIS HONOUR :-

F. W. Chapman *(AMATEUR)* A. W. Meeson *(AMATEUR)*
E. G. Davis *(AMATEUR)* A. W. Scothern *(AMATEUR)*
F. Hartley *(FULL & AMATEUR)* H. Smith *(AMATEUR)*
A. H. G. Kerry *(AMATEUR)* F. V. Spiller *(AMATEUR)*

THE FOLLOWING PLAYERS HAVE PLAYED IN AN F.A. ELEVEN:-

C. Saunders and V. Buswell.

The Football Association congratulates
the Club on its splendid record.

R. Graham CHAIRMAN OF THE COUNCIL

May, 1958

John W. Bowers CHAIRMAN OF THE F.A. AMATEUR
SELECTION COMMITTEE

Stanley Rous SECRETARY

STAFF SERVICE

Shop worker
Mr C.R. Pitt

This is an unusual illuminated address as it is addressed to C.R.P. in 1939, but has no other indication of who this may be. However, it arrived with another address dated 1938 to Mr C.R. Pitt. We are not told what names C.R. stand for.

Both presentations were from his employers, Debenham & Freebody. The first was to celebrate forty years of work since 1898, and the second was for his retirement the following year. Unfortunately, we do not know what role he had at the store.

There are twenty-four pages in a small folder, each with a pretty flower garland at each corner. Every page records the names of the staff of Debenham & Freebody in each of their departments, in alphabetic order. The capital initial of the department name is embellished, copying the practice of historic books of hours which often enlarged and highlighted the first letter of new sections of text. The departments include many that would not be readily recognised today such as Corsets, Fancy, Mantles and Tea Gowns.

In 1939, Debenham and Freebody was in a grand building at 27–37 Wigmore Street, London, a shopping street parallel and close to Oxford Street. The shop started as a drapers store in the eighteenth century. William Debenham joined the drapers and the shop name became Clark & Debenham. The business expanded and became Debenham, Son & Freebody in the mid-1800s, with shops in London, Cheltenham and Harrogate. The name Debenhams Limited was created in the early 1900s, but shops still retained their earlier names.

The address to C.R. Pitt given in 1939.

DEBENHAM AND FREEBODY

1898 — 1939

We, at Debenhams, desire to convey to you our Good Wishes on your retirement after forty-one years with us.

We trust you may have many years of good health in which to enjoy your well-earned leisure, and we ask you to remember us all as friends who will always preserve affectionate memories of you.

"Where true fortitude dwells, loyalty, bounty, friendship and fidelity may be found"

Sir Thomas Browne

Administrative

Miss R. Brown
Miss I. G. Howe
Mr. B. D. Pollard

Advertising

Miss V. Cowd
Mr. R. K. Sheppard

Approved Society

Mr. W. G. Bury

Artists

Miss I. Aberdeen
Miss K. Cooper
Miss G. Elgar
Miss T. M. Evans

Babylinen

Miss I. Humphreys

Miss J. Andrews
Miss M. Bandy
Miss B. Butler
Miss M. Coleman
Miss B. Edmonds
Miss M. Francis
Miss M. Goodwin
Miss B. Harper
Miss H. Henley
Miss I. Hodgkins
Miss M. Lassam
Miss J. Miles

Blouses

Miss A. Apted
Miss L. Barber
Miss D. Barnes
Mrs. Chettle
Miss R. Dean
Miss P. Freeth
Miss E. Hoile
Miss G. Holmes
Miss Kingsford
Miss J. Koczka
Miss M. Manley
Miss L. Neil
Miss A. Parsons
Miss M. Stocks
Miss Tudgay
Miss M. Vassilas
Miss I. Wadman
Miss B. Waterfield
Miss S. Watts

Catalogues

Mr. W. J. Wade

Mr. J. T. Allum
Mr. C. J. Bloomfield
Mrs. B. R. Box
Mrs. M. B. Bury
Mr. W. A. Francis
Mr. A. Jenkinson
Mr. H. J. Lawson
Mr. S. B. Massey
Mr. H. E. New
Mrs. E. M. Pemberton
Mr. W. Redhall
Mrs. Redhall
Mr. Chas. Rouse
Mr. F. J. Thompson
Mr. C. T. White

Railwayman
David Morgan

David Morgan was the Traffic Manager of the Rhondda Branches of the Taff Valley Railway in Glamorgan. He resigned in 1883 after thirty-six years of service and was given an unusual illumination with a beautiful blue edging.

The Taff Valley Railway was one of the oldest railways in Wales, operating from 1836 until 1922 when it became part of the Great Western Railway, and from 1948 part of British Railways. The railway was needed to transport coal and iron from the South Wales valleys ready for shipping.

George Stephenson built the first public railway line in the world to use steam locomotives in 1830. Robert Stephenson, George's son, designed Stephenson's Rocket in 1829, which was the most advanced locomotive of its time for the Liverpool and Manchester Railway and the basis for design of steam engines for the next 150 years.

However, it was Richard Trevithick who first built a high-pressure steam engine and the first working railway steam locomotive in 1804 for use in Merthyr Tydfil. The world's first steam train travelled from Merthyr Tydfil ironworks for 9 miles. However, this was short-lived, as the tracks were not strong enough for the heavy engine. Isambard Kingdom Brunel was asked to calculate the cost of a railway from Merthyr Tydfil to Cardiff in 1835 (£190,000) and a company, the Taff Vale Railway, was created in 1836. A Rhondda branch line was opened in 1841. At its height, the busiest station on the Taff Vale Railway, Pontypridd, with its one-third of a mile long platform, had two trains a minute passing. The trains carried both minerals and passengers.

The address to David
Morgan given in 1883.

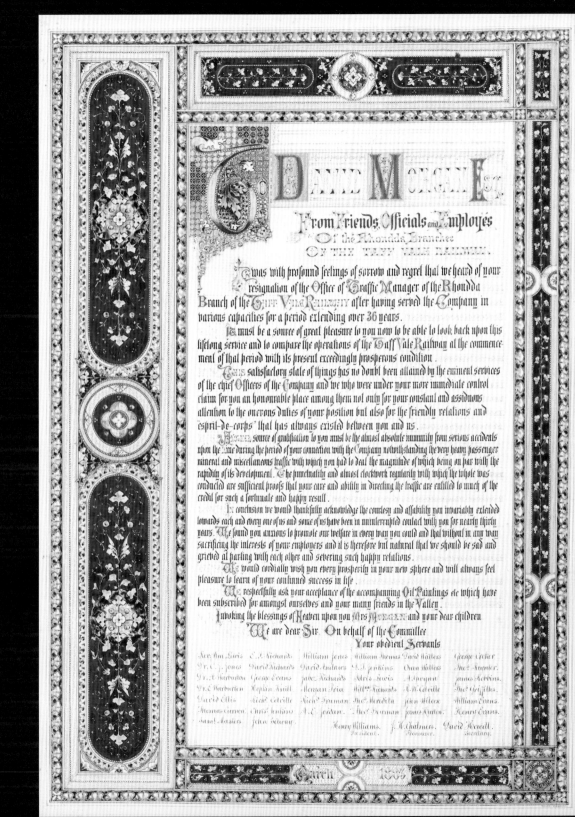

TO DAVID MORGAN Esq.

From Friends, Officials and Employés

Of the Rhondda Branches

OF THE TAFF VALE RAILWAY.

It was with profound feelings of sorrow and regret that we heard of your resignation of the Office of Traffic Manager of the Rhondda Branch of the Taff Vale Railway after having served the Company in various capacities for a period extending over 36 years.

It must be a source of great pleasure to you now to be able to look back upon this lifelong service and to compare the operations of the Taff Vale Railway at the commencement of that period with its present exceedingly prosperous condition.

This satisfactory state of things has no doubt been attained by the eminent services of the chief Officers of the Company and we who were under your more immediate control claim for you an honourable place among them not only for your constant and assiduous attention to the onerous duties of your position but also for the friendly relations and "esprit-de-corps" that has always existed between you and us.

Another source of gratification to you must be the almost absolute immunity from serious accidents upon the Line during the period of your connection with the Company notwithstanding the very heavy passenger mineral and miscellaneous traffic with which you had to deal the magnitude of which being on par with the rapidity of its development. The punctuality and almost clockwork regularity with which the whole was conducted are sufficient proofs that your care and ability in directing the traffic are entitled to much of the credit for such a fortunate and happy result.

In conclusion we would thankfully acknowledge the courtesy and affability you invariably extended towards each and every one of us and some of us have been in uninterrupted contact with you for nearly thirty years. We found you anxious to promote our welfare in every way you could and that without in any way sacrificing the interests of your employers and it is therefore but natural that we should be sad and grieved at parting with each other and severing such happy relations.

We would cordially wish you every prosperity in your new sphere and will always feel pleasure to learn of your continued success in life.

We respectfully ask your acceptance of the accompanying Oil Paintings etc which have been subscribed for amongst ourselves and your many friends in the Valley.

Invoking the blessings of Heaven upon you Mrs Morgan and your dear children

We are dear Sir On behalf of the Committee
Your obedient Servants

Rev. Wm Lewis	E. J. Richards	William Jones	William Thomas	David Walters	George Croker
Dr. C. J. Jones	David Richards	David Andrews	L. J. Jenkins	Owen Walters	Jno. Jupiter
Dr. A. Warburton	George Evans	Jabez Richards	Idris Lewis	A. Jorgyn	James Robbins
Dr. E. Warburton	Stephen Knill	Morgan Price	Willm Richards	A. W. Colville	Jno. Griffiths
David Ellis	Richd Colville	Richd Truman	Jno. Meredith	John Wilcox	William Evans
Thomas Curnow	Chris Jenkins	A. E. Jordan	Jno. Freeman	James Kirton	Henry Evans
Saml Masters	John Selway				

Henry Williams.
President.

J. H. Chalmers.
Treasurer.

David Howell.
Secretary.

March 1885

Water manager
William Terrey

In 1930, William Terrey was thanked by the Water Committee of Sheffield for his services as General Manager of the Water Undertaking by being presented with a fine illuminated address on his retirement.

Terrey had studied engineering at the University of Nottingham before joining the Nottingham Water Company as Chief Assistant to Henry Role MICE (Member of the Institution of Civil Engineers). He moved to Sheffield in 1888 when the Sheffield Water Works transferred from the company to the corporation. Sheffield was the first corporation to use compulsory purchase powers to take over its water supply. The corporation paid £2m.

William Terrey.

MEN OF NOTE

IN

THE WATER WORLD.

MR. WILLIAM TERREY.

Terrey was involved with a number of significant improvements to Sheffield's water supply. For instance, he was the principal witness in the promotion of a Bill for the acquisition of the waters of the Little Don Valley. He redesigned the reservoirs and pumping station and was recognised for saving the corporation a substantial £240,000. The Little Don rises in the Peak District and flows down into the River Don.

Terrey wrote about his work in *The Sheffield Water Supply*, published in 1929.

The address to William Terrey given in 1930, illuminated by C.W. Norris, 34 King Street, Cheapside, London.

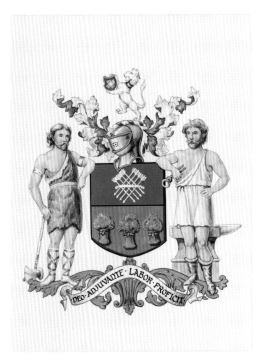

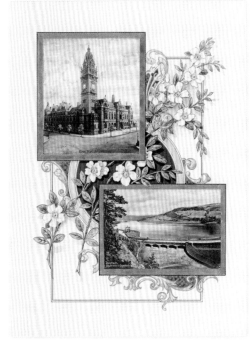

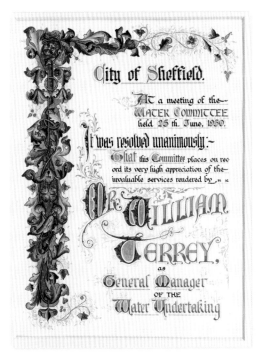

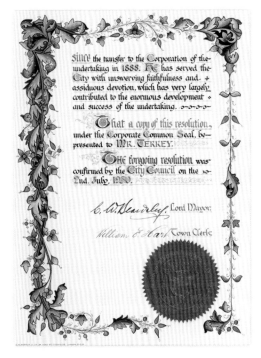

BANK OF ENGLAND

The directors

This is a simple illuminated address, given to the directors of the Bank of England at the end of 1945. It is in gratitude from the City of London to the Bank of England for storing archives and treasures during the Second World War.

The illuminated address has a nice signature of the City of London Town Clerk, Alfred Thomas Roach, based at the Guildhall. It also names 'Davis Mayor', Sir Charles Davis, who had been elected Lord Mayor of London in 1945.

The Bank of England was a good place for storing and protecting the City of London's archives. It has three floors below ground level and the gold remained in the sub-vault throughout the war years. The building was never hit by a bomb, but did receive minor damage when the road outside was hit.

The archives held by the Bank of England are readily accessed by viewing the online catalogue of archive records at www.bankofengland.co.uk/archive. It is also possible to visit the Bank of England and view the original documents.

The address to the directors of the Bank of England given in 1945, with the kind permission of the Bank of England Archivist, reference number (13A84/7/50).

Davis Mayor

A Common Council holden in the Guildhall of the City of London on Thursday the 29th day of November, 1945.

Resolved Unanimously :—

That the thanks of this Court be accorded to the

Directors of the

Bank of England

for much valued accommodation generously afforded for the safe storage of this Corporation's archives, books and antiquities during the period of hostilities.

That the thanks of this Court be also accorded to the Officers of the Bank for their constant care and help.

Roach

First published by Unicorn

an imprint of Unicorn Publishing Group LLP, 2021

5 Newburgh Street

London W1F 7RG

www.unicornpublishing.org

Text © John P. Wilson

10 9 8 7 6 5 4 3 2 1

ISBN 978-1-913491-37-6

Designed by Matthew Wilson / mexington.co.uk

Printed in the EU

All rights reserved. No part of the contents of this book
may be reproduced, stored in or introduced into a
retrieval system, or transmitted, in any form or by any
means (electronic, mechanical, photocopying, recording
or otherwise), without the prior written permission of
the copyright holder and the above publisher of this book.

Every effort has been made to trace copyright holders
and to obtain their permission for the use of copyright
material. The publisher apologises for any errors or
omissions contained within and would be grateful if
notified of any corrections that should be incorporated
in future reprints or editions of this book.